KELVINGROVE ART GALLERY AND MUSEUM

Glasgow's portal to the world

•

MURIEL GRAY

'Let the classes and the masses meet together at Kelvingrove, and, believe me good will come of it'

Letter to the *Glasgow Herald*, 31 August 1901

For Adam and Betty Gray

GLASGOW'S PORTAL TO THE WORLD

MURIEL GRAY

KELVINGROVE

© Text, images, illustration, design and typography Glasgow City Council (Museums), 2006, unless otherwise acknowledged.

ISBN 0 902752 79 0
ISBN 978 0 902752 79 5

Published by Glasgow Museums
Design, editing, photography, illustration, and index by Glasgow Museums Communications section. Thank you to staff at Glasgow Museums for their help with research, and in particular to Hugh Stevenson, Jean Walsh and Susan Pacitti for their assistance.

Printed in Scotland

Cover printed on GF Smith Zen Pure White 300gsm, text pages on GF Smith PhoeniXmotion Xenon 135gsm.

www.glasgowmuseums.com

CONTENTS

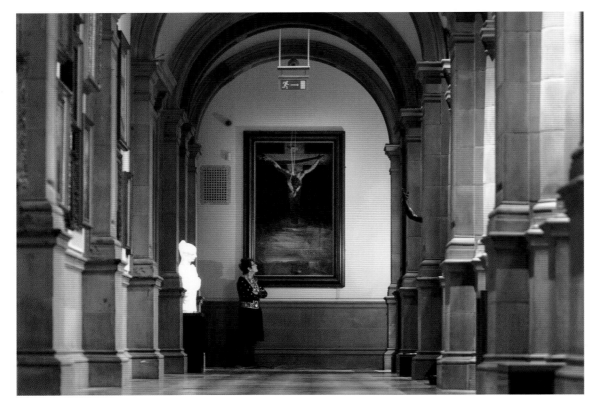

WELCOME TO KELVINGROVE

The relationship of the people of Glasgow with Kelvingrove is both extraordinary and unique. Few museums inspire such affection from such a wide range of people, and generation after generation is taken there by parents or grandparents. For me, as for hundreds of thousands of other Glaswegians, the childhood visit to Kelvingrove was a cultural anchor, a shared memory which is part of who we are.

Prior to its closure, more than one quarter of the 300,000 visits made each year by citizens of Glasgow was on foot – as I did when my father brought me here as a child, living in nearby Partick. The intimacy of this community relationship might be expected of a local history museum, but it is extremely unusual in an encyclopaedic museum with what Neil MacGregor, Director of the British Museum, described as 'one of the great civic collections of Europe'. Kelvingrove may be the only world-class neighbourhood museum in the world. It's a source of deep pride for everyone in Glasgow City Council who has had the privilege of taking part in the transformation of the wonderful place, and as we now welcome our fellow citizens back into

their greatly loved museum.

Kelvingrove also used to welcome 400,000 people from the rest of Scotland, and half of the 30,000 schoolchildren who visited the museum annually came from outside the city. This is the role of all great cities, where the concentration of residents, specialist skills and energy enables them to generate facilities which more dispersed communities cannot support. Glasgow demonstrated this commitment during the closure of Kelvingrove when, in 2005, we loaned an exhibition of 35 priceless Impressionist paintings to Kirkcudbright, in Dumfries and Galloway, with funding from the Scottish Executive. (Incidentally, our colleagues in the council there estimated that *Monet and the Impressionists* brought £2.2 million of additional tourist revenue to the area.) This sense of community responsibility is, I think, very Scottish, and a feature in particular of Glasgow culture.

In addition to its metropolitan function, Kelvingrove is also a destination for overseas tourists, helping to make Glasgow the third most-visited city in the UK. We are delighted to welcome people from all over the world, as well as the many Scots, and descendants of Scots, returning to the land of their roots. The City's collection of 1.4 million objects reflects Glasgow's global links – and global vision.

Kelvingrove was built largely from funds raised through public subscription, and the restoration has revived that great Victorian tradition. The Kelvingrove Refurbishment Appeal, led by the indomitable Lord Norman Macfarlane, raised over £12 million from many generous trusts, foundations, businesses and individuals. Over 4,000 people made donations, one third of them in memory of a deceased loved one, and we are very grateful to them all.

The restoration of the splendid building will be a revelation to all of Kelvingrove's old friends, few of whom could have imagined that it could be improved so much. The redisplay of the collections will also surprise, inspire and, in some cases, challenge both old friends and new visitors. The City's greatest treasures will be on display, but so will at least 5,000 objects never seen before. Most of the stories celebrate human creativity and the wonders of nature, but a few are challenging, confronting human destructiveness. Kelvingrove seeks to look life in the eye, and to enlarge the range of human experience with which museums engage.

So, on behalf of the City Council, its elected members and the staff who have worked so hard on this project, I would like to welcome our fellow citizens to their very own palace of the imagination. To those visiting Glasgow, I am sure I speak for everyone in the city when I offer you the warmest of welcomes, and invite you to explore life, art and culture in all its amazing diversity, in this truly wonderful museum. Welcome back Kelvingrove, our Palace of Dreams.

Liz Cameron
Lord Provost

Liz Cameron, Lord Provost of Glasgow, with Salvador Dali's *Christ of St John of the Cross*, Kelvingrove, 2006.

PREFACE

Kelvingrove is a very special museum. For generations of people from Glasgow and the surrounding neighbourhoods, it has a deep, personal significance linked with every stage of their lives. Visits to 'the art galleries' are highlights of childhood memories; young adulthood finds many courting and exploring the collections; parenthood and grandparenthood see the cycle begin again. All the while these visitors have grown to love individual objects, to develop favourites, which, like old friends, they drop in to see whenever they get a chance. Unlike many local perceptions of some cherished institution being special, the sense of Kelvingrove's uniqueness is not a myth. It is the largest civic museum and art gallery in the UK, and its collections are of international importance. Prior to closure, Kelvingrove's annual total of one million visits made it in absolute terms the most-visited museum in Scotland, and the sixth most-visited museum in Britain. But in relation to Glasgow's population of 600,000, it is the most-visited museum in any city in the UK. Kelvingrove is, to a very unusual degree, deeply embedded in the life of its city. It combines the qualities of a friendly local museum with world-class scale and quality.

Along with the quality of the collection and the scale of the building, this sense of local ownership has made the task of renewing the museum a heavy responsibility. Many people contributed greatly to the success of this huge undertaking. The project received invaluable input from a range of advisory groups. The Education Panel, representing every sector from nursery to university, emphasized the need to provide for self-directed learning for all ages, and for flexibility so that the museum could keep up to date. The Community Panel was made up of a wide range of people from across the city – from Community Councils to youth theatre groups and natural history societies. They emphasized the need to make everyone, no matter what their background, welcome, and to ensure that pre-visit information was widely available. And Glasgow City Council's Disability Forum ensured that every aspect of the project did not just meet current best practice, it also tried to anticipate future needs in an area where standards are rising all the time. The Junior Board helped ensure that the displays would be relevant to younger visitors, and, throughout the process, the Friends of Glasgow Museums provided invaluable support and a highly informed and passionate sounding board for ideas.

The project involved staff from right across the Council. Land Services provided a new landscape for the south approach; Development and Regeneration Services contributed a new floodlighting scheme; Direct and Care Services planned the new catering facilities – and the all important, but often forgotten, cleaning regime for the expanded building. Financial, legal, planning and many other expert sections had a vital input.

The City Council in general, and the Cultural & Leisure Services Committee in particular, have shown vision and fortitude in supporting the project. It's hard to remember now how daunting – some said unrealistic – the scale and ambition of the restoration scheme seemed ten years ago. And in this regard, special thanks must go to the Heritage

Lottery Fund, who awarded Kelvingrove its first and largest grant – a staggering £12.7 million, nearly 50% of the core project. This not only set the project up financially, but also indicated their confidence in Glasgow City Council's capacity to deliver, which inspired many other potential funders. Without the HLF grant, I have no doubt that the restoration of the entire building in a single phase would simply not have been possible. Significant funds were also received from the European Regional Development Fund, Historic Scotland and Scottish Natural Heritage. The Council's partnership with the private sector was embodied in the Kelvingrove Refurbishment Appeal (KRA). This innovative trust, chaired by the indefatigable Lord Norman Macfarlane of Bearsden, ran what turned out to be Scotland's most successful ever cultural fundraising campaign. The KRA enlisted the support of some of the country's leading business people as trustees and donors, and raised substantial sums from companies, trusts and foundations. Reflecting the unique role of Kelvingrove in the life of the city, donations were also received from over 4,000 individuals. In a unique gesture, there is no lower limit for the recognition of these donors, and all will be permanently acknowledged within Kelvingrove.

Anyone who has in any way contributed to the renewal of this great institution can feel proud of their achievement. On behalf of the City Council and the citizens of Glasgow, I would like to thank every one of them. The results of their efforts will ensure that Kelvingrove is in a position to serve the city and its visitors for another 100 years.

Councillor John Lynch
Convener, Cultural & Leisure Services

Councillor John Lynch with members of the Kelvingrove Junior Board.

FOREWORD

Mark O'Neill, Head of Arts and Museums, in the east court, Kelvingrove.

The restored and redisplayed Kelvingrove is the culmination of 15 years of work by hundreds of Council staff. Although the task of course mostly fell to Cultural & Leisure Services Museums staff, the scale and complexity of the project meant that nearly every Council service was involved at some stage. In addition to the work on the museum itself, the project involved designing and building the £7.4 million Glasgow Museums Resource Centre to house the 200,000 objects formerly stored in Kelvingrove, freeing up the basement for new public facilities; mounting the major exhibition Art Treasures of Kelvingrove in the McLellan Galleries; and touring 65 Impressionist masterpieces to North America and Spain to help fund the restoration. And while all this was going on, the City's other museums maintained a busy and exciting programme of exhibitions and events (including increasing the number of school visits), providing a service to local people as well flying the flag for Glasgow as a cultural tourist destination.

The architectural strategy for Kelvingrove was simple: to restore it to its Victorian just-built condition while modernizing all the services for 21st-century visitors and 21st-century technology. The building hadn't been rewired since 1899, and over the years partitions had been erected to create offices, meeting rooms and education spaces. These functions were moved to new public areas in the lower ground floor, and the building's original vistas and circulation patterns restored. The Kelvingrove you'll see today is much airier and brighter, allowing greater appreciation of the original colour scheme and architecture.

We've created new displays, not just updated the old galleries, which involved a complete rethink of the philosophy of the museum. The displays are based on an assessment of the most interesting objects, or groups of objects, amongst the 1.4 million in the City's vast collection. Curators proposed over 200 stories, whittled down to the 100 on display. Each of the 8,000 objects was cleaned and, if necessary, restored by conservators, and each had to have a new display mount designed and made.

Keeping track of objects as they were

processed and then installed was in itself a mammoth task, carried out admirably by the Collections Management, Logistics and Decant teams. Each object is part of a story, written and edited to rigorous standards of research and accessibility – the displays involve a total of nearly 250,000 words. To put the objects in their cultural or natural contexts, nearly 10,000 photographs were selected by curators and ordered from museums, libraries and individuals all over the world by the Photo Library staff. And throughout it all, our photographers documented the project.

We haven't chosen one single display method – every story is communicated in the way that worked best for its content and its envisioned audience, with supporting audiovisual materials when appropriate. Perhaps the greatest challenge was organizing the vast range of material and display approaches into a coherent whole, to ensure that the museum had a sense of unity. This was the task of a core Project Team. As well as coordinating the work of the architects, builders, external designers, Council staff and many specialist consultants, they have ensured that every dimension of the new displays reflects the overall vision for Kelvingrove.

Evolved over decades, the key elements of Glasgow City Council's vision for Kelvingrove are that the displays are object-based, inspiring appreciation and learning through real things. We wanted to introduce the best modern display methods – but not at the expense of objects. This is the basis of our commitment to double the number on display, from 4,000 objects when we closed, to 8,000 today. Kelvingrove aims to welcome every visitor, no matter what your background or prior knowledge, and to provide a way in to understanding the wonderful objects on display. We undertook extensive consultation with visitors and non-visitors, as well as keeping up to date with the latest psychology of communication and learning, and all this informs the displays.

Rather than summarizing subjects (like art history, archaeology or geology), we've concentrated on telling the most interesting stories about the most interesting objects. By focusing on the strengths of the collection, we don't have to fill 'gaps' with graphics or 'books on the wall'. By using narrative rather than the structure of subjects, the displays are able to function at many different levels – accessible to the novice, but resonant for the more knowledgeable visitor.

Because each of the 22 galleries displays four to eight separate stories under a broad theme, we can change individual stories without having to redisplay entire galleries. This is one of Kelvingrove's major innovations – it's a genuinely flexible museum. By changing three or four stories a year, it can evolve over time, remain up to date and we can respond to new discoveries and public interests.

Everyone who contributed to the restoration and redisplay of Kelvingrove is deeply aware of the privilege it has been to work on such a wonderful project, but I would still like to thank them for all their hard work. I'd also like to thank Muriel Gray for agreeing to write this book, and for communicating her affection and enthusiasm for Kelvingrove so well.

We hope we have done something approaching justice not just to the fabulous building and the amazing collection, but to the special place this greatly loved museum plays in the life of Glasgow.

Mark O'Neill
Head of Arts and Museums

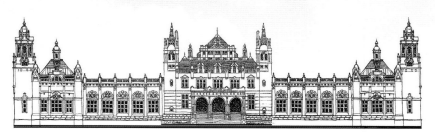

KELVINGROVE REFURBISHMENT APPEAL

Lord and Lady Macfarlane at the *Monet and the Impressionists* exhibition, Kirkcudbright.

Opposite:
The restored centre hall, Kelvingrove, 2006.

Kelvingrove Art Gallery and Museum is hugely important. The epitome of Victorian enterprise and initiative, this magnificent and much-loved building has brought the world of art, history and natural history to life for generations of visitors over the last 100 years. Kelvingrove holds a special place in people's hearts. Any Glaswegian, Scot or visitor to the city who has spent a pleasant afternoon surrounded by some of the finest treasures in the world cannot fail to share the joy it has given me since my childhood. I have always regarded it as my Aladdin's cave.

It has been my privilege to be involved with Kelvingrove in many ways over the years. In particular, as Chairman of the Kelvingrove Refurbishment Appeal, I am proud to have contributed to the exciting and visionary restoration of this wonderful place.

I hope that you will enjoy reading about, and visiting, this exceptional legacy of Glasgow's proud past, and remember with me the thousands of people who supported the Kelvingrove Refurbishment Appeal 2002–2006. They are commemorated in the grand centre hall, and are forever part of the history of Kelvingrove.

Lord Macfarlane of Bearsden KT
Chairman

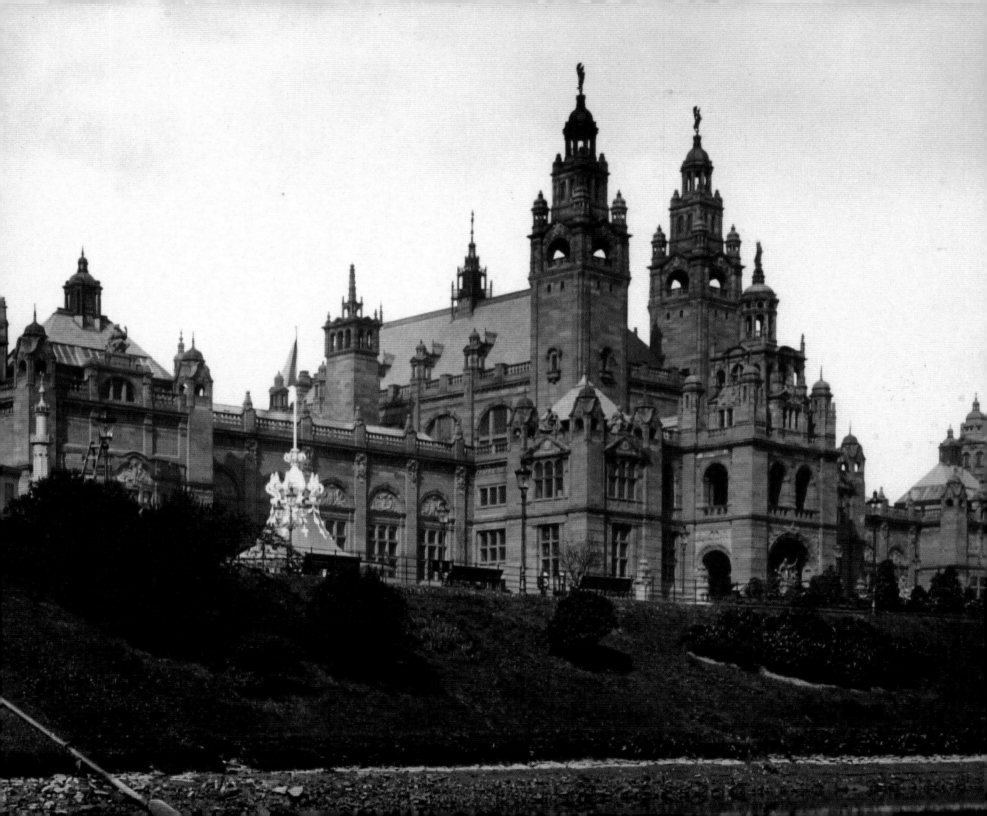

INTRODUCTION

Muriel Gray in Kelvingrove, 2006.

Most cities boast large civic buildings, but it's a unique event when a single structure not only captures the hearts and imaginations of its citizens, but somehow succeeds in embodying the very spirit of the city itself. The towering red sandstone magnificence of Kelvingrove Art Gallery and Museum effortlessly performs this function on behalf of Glasgow, and then goes so much further. There is something indefinably magical about the building – everyone who has visited it, grown up with it as part of his or her cityscape, or simply engaged with it at any level, automatically regards this shared public space as having deep, personal resonance.

Ask any Glaswegian for their memories or impressions of Kelvingrove and emotions will pour out, emotions that few would normally associate with the traditionally stiff formality of an art gallery and museum. People remember arranging clandestine rendezvous with their first loves in the fairytale setting of the marble floored arcades, or marvelling as children at the cased menagerie of stuffed wildlife, frozen by skilled taxidermists in dramatic tableaux of flight, fight and feeding.

Everyone seems able to conjure up a treasured painting that captured their imagination and stayed with them, or a favourite exhibit amongst collections as diverse as bloodthirsty weaponry, delightfully tattered dinosaur models, spooky Egyptian sarcophagi and exquisite scale model ships. But common to all who have cherished these delights is a love of the building itself.

My own father, a born and bred Glaswegian, described it proudly as 'A portal to the world and everything in it'. Indeed, as a child, when we climbed the wet granite steps from a dingy, rain-lashed Argyle Street and entered the doors into the breathtaking majesty of the centre hall, the portal was so enchanting that for the duration of our visit the city outside ceased to exist.

Left: Kelvingrove from the River Kelvin in 1901.

To my child's eye, everything was beautiful. The stonework, even coated in its pre-restored grime, boasted a combination of monumental scale and delicate detail that filled the mind with images of palaces and fairy castles. The light fittings, the marble floors, the endless arched arcades, sweeping staircases, and elegant, towering windows inspired awe without intimidating. Perhaps it is this rare characteristic that leads Glaswegians to embrace the building as a physical expression of our city's ambition of international status combined with social equality.

In an abstract expression of egalitarianism, the architecture of Kelvingrove seems designed to be indifferent to the status of those it serves. No vaulted space, airy gallery or elaborate corridor aims to belittle those who inhabit them. Instead, the building effervesces with joy in its own restrained opulence, inviting everyone to share in the wonder of our astonishing capabilities. The scale may at times be breathtaking, but it offers nooks and crannies of domestic proportions that have made many a child fantasize about moving in and setting up home on some perfect balustraded landing.

While the interior of Kelvingrove has the easy task of igniting the passions of every class

and age of visitor, given the endless fascination of the collection and the splendour of the architecture, the exterior inevitably has the harder job. The site is not one that allows the building to dominate the cityscape in the way that Glasgow University does from its lofty hilltop position. Since Kelvingrove's towers and domes can't be seen from any great distance, save from the back of the university building or a sliver of crescent that runs round Park Circus, it's only the passer-by on Argyle Street or the park visitor who encounters the full impact of the architecture. Here again, however, its countenance is so boldly romantic – a red sandstone fantasy punctuated with intricate Hispanic towers encrusted with sculpture and heraldry.

When these contours glow with an alien Mediterranean warmth that even the most watery Scottish setting sun ignites, it's little wonder that the building has its own mythology. We were frequently told as children that the architect had jumped to his death from one of the topmost towers on discovering that his masterpiece had been built back to front. This urban myth seems hilariously improbable as an adult, when one ponders, that over the course of eight years of construction work, what kind of grown man might not notice until the very last minute

One of Kelvingrove's hidden staircases.

that something was awry? Can we really imagine the cry of 'Blimey, where's the front door? Oh no! It's at the back. Goodbye, cruel world'?

The rumour, of course, has its origin in the fact that the building was constructed to be approached from the park during the 1901 Exhibition, then a considerably more popular thoroughfare than Argyle Street. But, since no other public building in Glasgow has such a melodramatic legend attached to it, this once again proves the special regard Kelvingrove is held in.

In fact, the news that the art gallery and museum was to close for three years was met

with mixed emotions from its supporters. On one hand, it was generally agreed that it was a project on the verge of being overdue. A century of grime had coated the stone, the wiring hadn't been renewed for 100 years, and the displays had been left untouched for so long – some in Edwardian cases with charmingly curled little pieces of yellowing card – that they had almost become exhibits themselves, demonstrating what museums of old used to be like. But, on the other hand, the affection for the place is so acute that many people felt they couldn't live with the doors being closed for so long. Those with small children grieved that those little people's short childhoods would miss out on the magical days spent browsing amongst stuffed eagles and thrilling paintings.

However, the restoration was almost unanimously welcomed, and the magnificent, refurbished, repaired, redesigned gem that now presents itself to the world, its best features preserved forever and its defects gone, projects the building and collection into a whole new era of discovery and joy for generations to come.

For me that portal is as magical as ever, and as a Glaswegian I find myself much more than simply proud to walk through Kelvingrove's doors into this next stage in the building's life. I am taken straight back to the delights of my childhood and, in common with almost everyone who tentatively pushes open the doors in anticipation of seeing the alterations to something they have always loved and cherished, I am delighted, astonished and excited to welcome back such a precious old friend.

Muriel Gray
Glasgow, June 2006

View from the Glasgow University tower in 2006.

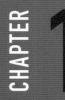

THE BEGINNING

Kelvingrove: Glasgow's portal to the world

Nineteenth-century Glasgow

At times it is uncomfortably apparent that modern Glasgow, in common with most post-industrial cities, still suffers from a shocking division between its richest and poorest citizens. But Glasgow in the nineteenth century was an even more polarized society. Through shrewd investment in the lucrative businesses of cotton, tobacco, iron, steel, locomotive and shipbuilding, as well as financial trading, Glasgow had become one of the most important industrial and commercial cities in Europe. As a result, its top entrepreneurs were people of enormous wealth and expensive tastes. This status they made manifest in many ways, perhaps most visibly by building ostentatiously grand villas in town, buying country estates, and setting up equally impressive second homes, particularly along the Clyde coast. Their yachts would ferry them there at the weekends, so they could escape the urban grime.

It's sobering, for instance, to realize that the great Kibble Palace, the enormous and elegant glasshouse now magnificently refurbished in Glasgow's Botanic Gardens, started life as a private conservatory for engineer John Kibble. This was part of his holiday villa on the Kilcreggan peninsula, until he decided to bequeath it to the city, dismantling and shipping the conservatory to Glasgow where the dome was slightly enlarged and two wings were added. Clearly the idea of a conservatory to our rich Glaswegian forebears was something a little more substantial than somewhere to place a couple of rattan chairs and read the Sunday papers.

A Divided City

But in addition to their fondness for grandiose displays of material wealth, the nineteenth-century Glasgow bourgeoisie prided themselves on their cultural sophistication. Many were highly educated, and participated enthusiastically in the tradition of completing the Grand Tour, that pilgrimage to Europe's most important centres of art, philosophy and ancient civilization. It was also demonstrable in their artistic preferences, which were largely urbane, refined and anything but provincial.

Great personal wealth, however, is seldom attained without consequences. Fortunes were built on the toil of poorly paid workers, many of whom lived in slums of such appalling squalor that child mortality rates were on a par with third world countries, and whose living conditions in overcrowded, rat-infested tenements were unimaginable to most of us today.

Mid nineteenth-century Glasgow, therefore, had the dual reputation of being a hotbed of enterprise and commercial innovation, and also a city with enormous social problems. Its governing body was not blind to this injustice, and its members embarked upon a number of ambitious and altruistic schemes to improve the lives of those trapped by poverty and dogged by ill health. These included the implementation of a fresh, clean water supply to all homes by the construction of the engineering wonder that to this day still brings the Highland waters of Loch Katrine over 50 miles of countryside to the taps of Glasgow; and the City Improvement Trust, a body entrusted to do precisely what its title implied. The Trust moved substantial numbers of people out of the slums into new accommodation, and embarked on a large-scale project of demolition and rebuilding.

Despite their ruthless exploitation of a desperate working class being responsible for

much of the human misery that had made these improving schemes necessary, Glasgow's elite industrialists, merchants and businessmen nevertheless also displayed a great deal of idealism and philanthropic intent. There was a consensus among them that Glasgow was lagging behind its rival industrial cities – such as Liverpool, Manchester and Edinburgh – in the civic provision of cultural diversions for its masses.

In search of immortality?

The firm belief that an appreciation of the high arts was as essential for the well-being of mankind as food, drink and shelter was widespread in Victorian times. Glasgow seemed to feel it most acutely, judging by the generous bequests that the city enjoyed from its grandees. The judgement that these were a vain quest for immortality seems a little harsh. Perhaps, more mundanely, they arose from a straightforward sense of civic pride and duty, or a bending to social pressure on those wishing to enjoy active public life. If we wish to be even kinder, then let's also assume that the cultural legacy of Robert Burns's egalitarianism, during the Enlightenment of the previous century, had genuinely persuaded them that it was their duty to assist in the

cultural betterment of their fellow citizens. Whatever the real motives, there were few wealthy individuals who did not contribute in some way or other to public projects and endeavours designed to do just that.

Archibald McLellan

Archibald McLellan was one such man. Born in 1797, he later became a partner in his father's coach building business. Although it appears he gave it his best shot at following in his father's footsteps as the master of a mechanical industry, the quality of his education moulded him into a scholar and aesthete. It quickly became clear that his interests were far more to do with the arts than the finer points of construction, forged metals or paintwork finishes.

Having discovered his real passion, he devoted most of his energies to pursuing this interest and taking an active and important role in Glasgow's public life. He became Deacon Convenor of the Trades House, a magistrate at the tender age of 25, and a prominent member of the Town Council. He was more likely to be found in the society of contemporary artists, musicians and writers than that of minor politicians, and he counted amongst some of his close friends the artists

The Stewart Memorial Fountain in Kelvingrove Park celebrates Glasgow's famous water supply.

...the nineteenth-century Glasgow bourgeoisie prided themselves on their cultural sophistication.

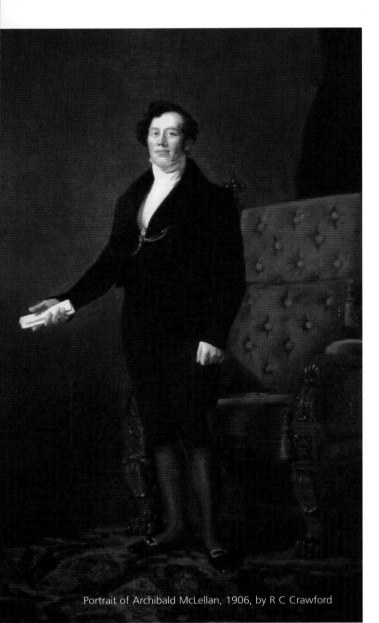

Portrait of Archibald McLellan, 1906, by R C Crawford

Sir Francis Chantrey, Sir David Wilkie and Sir Daniel Macnee.

'For the behoof of the citizens of Glasgow'

McLellan's personal funds were, therefore, not unsurprisingly channelled towards creating a significant and impressive collection of paintings, gold and silver plate, sculpture and a fine library. It had always been his intention to gift this entire collection to the City for 'the behoof [benefit] of the citizens of Glasgow in all time coming', and a gallery in which to house it. Ironically, the construction of this building, the eponymous galleries in Sauchiehall Street, formed part of a series of poor decisions in property dealing that left him insolvent on his death. The bequest to the City, therefore, was left in the hands of the trustees of his estate, and Glasgow Town Council had to decide whether to pay the asking price of £44,500 for the collection and the galleries, or risk seeing it sold to private bidders. It was not a decision without argument and controversy, but since Glasgow lacked any significant art collection, the move to accord with McLellan's wishes was taken and Glasgow's first major art collection was duly purchased in 1856.

The painting collection, which, given McLellan's principle interest in Italian Dutch and Flemish art, was heavily weighted towards Old Masters, had been on display in the McLellan Galleries from 1855. But if the city fathers were expecting the public to flock to their new purchase, they were to be a little disappointed. Interest in Old Masters and classical sculpture was not as pronounced as today and, if attendances were anything to go by, the nineteenth-century Glaswegian appears to have had more contemporary tastes. Perhaps the access to the Galleries dissuaded citizens from taking the venue to their hearts, since it was then, and still is, a relatively subtle and small entrance that gives little hint of the grander space to which it leads. Enticing the casual passer-by requires skilful design, and the Sauchiehall Street front door fell short. Add to this a slightly stuffy, crowded hang of pictures and figurative sculptures arranged like an unruly bus queue, and one can see why it didn't immediately ignite imaginations.

Whatever the reason, the Galleries were used mostly for functions, and while this was pleasant for those who enjoyed a glass of wine with their backs to a Dutch Old Master or conversing under a marble nymph, it was hardly the original intention of Archibald McLellan. However, when one JC Robinson (a

man with the unlikely title of Her Majesty's Surveyor of Pictures) visited the collection at the invitation of Superintendent James Paton, gave it a thorough inspection, weeded out nearly 70 paintings he considered of little value, and gave it a resounding thumbs-up, Glaswegians were alerted to the fact that they had something rather special in their possession.

Curios from around the world

Another museum, the City Industrial Museum, had opened in 1870 in a vacant elegant mansion in Kelvingrove Park (*pictured right*). Originally built in the late eighteenth century for Patrick Colquhoun, Provost of Glasgow, it contained a bewildering variety of objects that embraced not just technology and industrial heritage, but also a natural history and anthropology collection that ranged from the impressive to, quite frankly, the absurd.

Wealthy Glaswegians who travelled invariably brought back trunks of souvenirs to bequeath to the city, sometimes with the enthusiasm of amateur naturalists, archaeologists or historians wishing to share their passion with a wider audience, and sometimes with the barely disguised intention of marking their own social importance.

Whilst those early contributors with a serious interest in ethnology and natural history gifted specimens of genuine and lasting interest, the museum was inevitably inundated with an assortment of less auspicious items, from the thoughtlessly gathered curios that were all but looted from their unfortunate owners, to sacks of unsorted rocks. Add to this the assortment of flora, fauna and carrion that Scottish landowners found lying about on their Highland estates and felt compelled to contribute, and the potential was there for an overcrowded and

Above left: *Interior of McLellan Galleries, Glasgow, c.1860,* by Mark Dessurne.

Above: The Ancient Order of Foresters posing outside the City Industrial Museum c.1873.

Wealthy Glaswegians who travelled invariably brought back trunks of souvenirs to bequeath to the city...

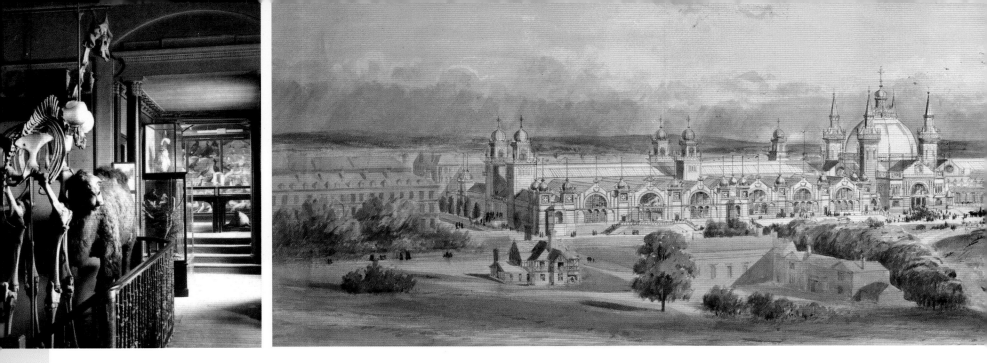

incoherent collection of junk. Great credit is therefore due to the curators who sifted out all that was wonderful, illuminating and important from this potentially baffling mountain of material, and gave birth to the marvellous and coherent collection we now enjoy at Kelvingrove.

Early treasures donated at this time included the complete skeleton of the moa (a long extinct New Zealand bird), an intelligently gathered collection of minerals and shells from Dr J Dougal, and artefacts brought back from the historic and internationally famous explorations of David Livingstone. The museum was a bigger draw than the art collection in Sauchiehall Street, and in 1876, with the help of a public subscription, an extension that proudly housed an aquarium

was added. The temporary exhibition of local industries that marked its opening was so successful that its popularity was described as 'embarrassingly great' by the Sub-Committee of Parks and Galleries Trust. They also noted their regret at the difficulty in controlling the crowds eager to see it.

James Paton and the 1888 Exhibition

The McLellan Galleries and the City Industrial Museum were jointly supervised by James Paton, the very first Superintendent of Museums, and the human manifestation that Glasgow had finally acquired civic collections of note. His appointment was an important development, as he was a man with a modern

vision of how Glasgow's collections should be housed and interpreted. His view was that they should interest and entertain the public, but also that the diverse and seemingly unrelated exhibits in the City Industrial Museum and the McLellan Galleries could be better combined to make more sense and to educate.

Inspired by visits to museums and art galleries in Europe, Paton came to the conclusion that neither of Glasgow's venues was ideal for such a vision. In 1886, a report by Paton and Bailie Dickson, Chairman of the Council's Museum and Galleries Sub-Committee, expressed the opinion that the McLellan Galleries were a fire hazard and that the collection would be better served in a new purpose-built property in Kelvingrove Park. Few disagreed, and it was subsequently decided

that a new building would encompass an art gallery, museum and art school, all on the same site. Here was a wonderful opportunity, and the vision of elevating Glasgow onto the same plane as its rival cities, already in possession of impressive civic art galleries and museums, was grasped with gusto.

The 1888 Exhibition

To raise funds for the ambitious venture, the City decided to hold an international exhibition. The first 'world fair' had taken place in London in 1756, with the French adopting the tradition in earnest from the 1790s onwards. However, the 1851 Crystal Palace exhibition in London – the Great Exhibition of the Works of Industry of All Nations – set a new standard and vogue for

grand exhibitions of industry and culture. It focused on the international progress of the arts and industry, and was an educational and entertaining day out. Later exhibitions introduced amusements, in theme park style. And it seemed that the public's appetite for such events was insatiable.

Paton had witnessed first-hand how popular the 1878 Paris International Exhibition had been, and had made numerous contacts there. This was to be Glasgow's first exhibition, and the site agreed upon was, logically, the pretty riverside, leafy, grassy, expanse of Kelvingrove Park.

The Prince and Princess of Wales opened the Exhibition on 8 May 1888. Almost six million people visited it, including Queen Victoria who visited twice – once on an official

Opposite page left: Natural history exhibits in the old City Industrial Museum.

Above left: International Exhibition building, Kelvingrove, 1888, architect's drawing by James Sellars.

Above: Queen Victoria at the 1888 Exhibition.

visit on 22 August, and two days later on a private visit. When the gates closed in November, the profits amounted to an admirable total of about £43,000. Subscription increased this to £130,000, and it was with this sum in the coffers that the Association for the Promotion of Art and Music launched a competition to design the new art gallery, museum and school of art.

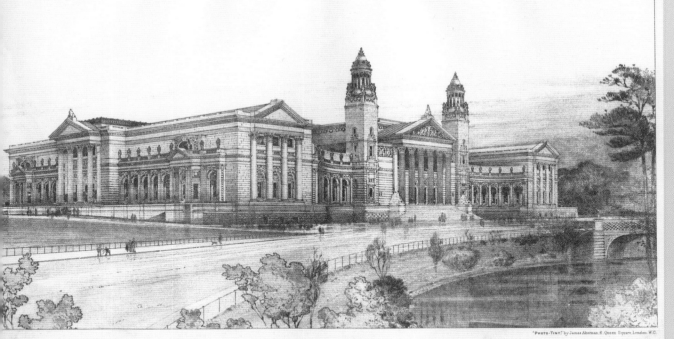

'PHOTO-TINT' by James Akerman, 6, Queen Square, London, W.C.

The Competition

This unique opportunity naturally ignited interest from a broad range of architects, both from within and without Scotland. From an initial entry list of 62 designs, six were shortlisted. The final six were by Malcolm Stark and Rowntree from Glasgow; Thomas Manley Deane from Dublin; Treadwell and Martin from London; John W Simpson and EJ Milner Allen from London; and two designs from the celebrated Glasgow architects John Honeyman and John Keppie.

It's fascinating to examine these designs and consider what place Kelvingrove might have found in Glaswegians' hearts had the eventual decision been different. Neo-classicism loomed large amongst the hopefuls, and typical was the monumental, multi-columned affair submitted by Malcolm Stark and Rowntree (*pictured*), with unsubtle echoes of the British Museum in London. Thomas Manley Deane and Treadwell and Martin's schemes were safe and solid, following similar lines of corner-turreted scholarly buildings. The two designs submitted by Honeyman and Keppie, the architects who famously employed Charles Rennie Mackintosh, later to be designer of Glasgow's exquisite School of Art, were quite distinct. One boasted a bold ecclesiastical central dome, whilst the other followed the safer lines taken by Thomas Manley Deane and Treadwell and Martin, but with perhaps a slightly finer eye to composition and detail. Mackintosh's exact involvement in the Kelvingrove submission is unclear; some sources suggest that he had an unsigned hand in the early drawings of one of the two shortlisted Honeyman and Keppie designs. However, if indeed he was in any part influential in the submissions, there is little to suggest the later Mackintosh style that made his work, and the city that boasted it, internationally famous.

The winners

The winning design was submitted by two English architects, Simpson and Allen, a decision that was not without the usual grumblings from those individuals, particular to every century, who believe that local architecture should be exercised only by locals. (Eyebrows had been raised in a similar fashion when Glasgow University's design had been awarded to the English architect Gilbert Scott, with Glasgow's famous Alexander 'Greek' Thomson at the forefront of furious protests that an unprecedented Gothicism had been introduced into a city so in love with neo-classicism. Much of this criticism was subsequently silenced when the building was completed and declared almost universally a bold move and a popular success.)

Since the judge of the Kelvingrove Art Gallery and Museum competition was also an Englishman, the Manchester-born architect of London's Natural History Museum, Alfred Waterhouse, and significantly an ex-tutor of the two winning designers, there were doubtless mutterings not just about an absence of Scottish talent, but also about possible bias.

But any sour grapes must surely have been squashed on seeing the magnificent scheme developed by Simpson and Allen, as it stands out from the other five in the scale of its originality and confidence. The style has been described as Hispanic baroque, and although the exterior, and the skyline in particular, suggests an almost bewildering complexity, the internal plan is simplicity itself. The western and eastern courts are separated by a grand centre hall measuring 125 feet long by 56 feet wide, with galleries and promenades encircling the courts at both ground and first floor level. Two magnificent staircases, in line of sight east and west, take you to the upper galleries, where the continuous arched passageways allow a view below over elegant balustrades. In short, Simpson and Allen's design was sufficiently flamboyant and dynamic to excite, but also a model of straightforward logical simplicity in its planning. The City had found what it was looking for.

The decision was taken not to include a school of art, and with hindsight we can see how fortunate this was. Despite the splendour, success and popularity of Kelvingrove Art Gallery and Museum, the eventual Glasgow School of Art designed by Charles Rennie Mackintosh is in a different league altogether, being unarguably a timeless masterpiece to rival any in the world. How tragic it would have been if the opportunity had never arisen for its conception.

Simpson and Allen's prizewinning design.

'Simpson and Allen's design was a model of straightforward lyrical simplicity'

Kelvingrove nearing completion.

Construction begins

Construction of Kelvingrove started when ground was broken in 1893, and the basements were completed by June 1895. There is such a grand tradition of public buildings being budgeted at a reasonable sum and finishing up costing many times more, that such predictably poor accounting should almost be a recognized discipline in itself. Kelvingrove was no exception to this. By 1896 the original projected budget of around £120,000 had already risen, and since the Association for the Promotion of Art and Music foresaw funding problems, the project was transferred into the hands of the Town Council.

It was then, with this financial discrepancy to tackle, that the decision was taken to mount another international exhibition to coincide with the opening of the building. The date was set for 1901, and all concerned were expected to make every effort to meet this immovable deadline.

The sculptures

After yet another competition in 1898, the building's flagship sculptures were put in the hands of George Frampton, one of the country's leading artists. Today he is perhaps best remembered for a later work, the 1912 statue of Peter Pan in London's Kensington Gardens. Frampton sculpted the magnificent bronze group that looms above the north door of Kelvingrove, that of St Mungo (*pictured on p.5*) as Patron of the Arts. His other works included relief carvings representing music, literature and manufacturing arts in the spandrels of the north, east and west arches of the entrance porch, and 'The Great Trio of Greek Art' – Pheidias (sculptor), Ictinus (architect) and Apelles (painter) above the attic windows on the entrance porch.

The other principal sculptor was Francis Derwent Wood RA, whose carved figures above the north entrance depict Music, Architecture, Sculpture and Painting. Derwent Wood was briefly a tutor at the Glasgow School of Art, and his influence, by example of his Kelvingrove work, cannot have failed to have had an effect on Glasgow's public sculpture that followed. Also featured was the local sculptor A McFarlane Shannan, who later created Lord Kelvin's monument in Kelvingrove Park. He was responsible for three huge bronzed winged figures on the main towers and on the portico, which have sadly now been lost.

Unseen beauties

Many other less celebrated, but nevertheless talented, sculptors were responsible for the rich variety of carvings and figures that encrust the complex exterior of the building. The positioning of their work highlights a most curious fashion in Victorian architecture. It would be ludicrous to imagine a modern artist of any note agreeing to produce work that would be sited where it could never be viewed, yet Kelvingrove's topmost towers boast works of exquisite craftsmanship and detail that are in just such an unfortunate position. High above street level, on the towers that cluster around the steeply sloping roof of the centre hall, lions support carved columns or sit proudly on their own stone pillars, and the faces of cherubs, each one unique, peer from the supporting corbels, and fill the gaps between elegantly fluted stone work. Yet these lovely pieces of work cannot be seen by anyone at all, lest visitors risk their lives by clambering around on the rooftop. It may seem strange to us that an architect would have wasted time and money embellishing areas that would only ever be gazed upon by, at worst, mating pigeons, and at best, by busy hard-hatted maintenance workers. Yet it's an indication of Simpson and Allen's Victorian ideal of the building as a perfect entity in itself, almost in spite of any critical viewer, rather than a showy façade at street level that peters out to the mundane.

The stone details inside the building were crafted as exquisitely as the exterior, with carving and relief works that represented everything from great Scottish heroes and the ancient guilds of Glasgow to famous European composers.

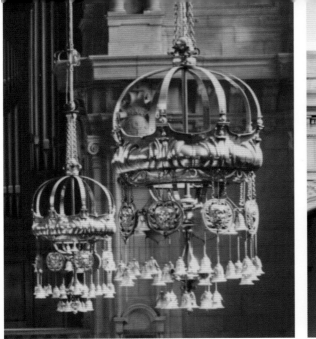

Inside the building

Whilst the exterior was of the delicious deep red sandstone cut from the Locharbriggs Quarry near Dumfries, a stone used so extensively throughout Glasgow in the late nineteenth century that many would say it's the visual signature of the city, the interior was clad in a lighter blond sandstone from a quarry in Giffnock, on Glasgow's south side. Of course, given that the city was powered by coal from the building's birth right up until the Clean Air Act of 1956 forbade the use of sulphurous fuels in town, neither the exterior nor the interior were able to retain the clarity of their tone for very long before pollution dulled their rich hues. By nature of its light colour, the interior suffered most, and the excitement of seeing the stone restored to its

natural state in 2006 should not be lost on this generation, the first to see it this way since it started to discolour almost from the moment it was built.

The stone details inside the building were crafted as exquisitely as the exterior, with carving and relief works that represented everything from great Scottish heroes and the ancient guilds of Glasgow to famous European composers. The rich panelling on the ceiling of the centre hall masks the fact that it is an early example of cast concrete. The building was one of the first in Glasgow to boast electric instead of gas lighting and, in the roof void above the ceiling, the great art nouveau light fittings were tethered above this concrete shell by a winding system that required a precision operation to change a light bulb. One man had to unwind the chain

in the gloom above this concrete shell, quite cut off from his companion below in the centre hall. He would only stop winding when he heard his colleague give a sharp whistle to indicate that the light was nearly at ground level. A moment's inattention, and the great brass and glass fittings would have crashed onto the floor and been ruined.

The floor that would have claimed them was a beautiful, polished chequerboard of mixed marble from Italy, Belgium and Norway. The use of this through the building at both ground and first floor level imbues it with a luxury that is punctuated by the textural simplicity of the great stone staircases. All the other floors were made from polished teak, and the joinery work was walnut, providing a tonal and textural warmth that offset the cool elegance of the sandstone and multi-coloured grandeur of the marble.

The design of the upper galleries was deliberately more subdued, in order not to detract attention from the paintings they would house, and here the lighting was mostly natural, coming through the glass roof lights. Another feature the modern visitor can now enjoy for the first time is the natural light newly released into the centre hall and upper corridors from windows that had been blocked by temporary panelling. Simpson and

Princes Louise, Duchess of Fife, surrounded by worthies, opened the new Kelvingrove on 2 May 1901.

The final cost of construction was the heady sum of £204,712, one shilling and sixpence.

Allen clearly understood the aesthetic values of natural light, and used the stellar compass point orientation of the building to great effect, before administrative considerations thwarted their grand design with the depressing light-excluding hessian-covered partition boards that are ubiquitous in most public buildings. In addition, the architects had a mature grasp of how crowds move through a space. When the building was first erected, the flow pattern was clear and simple – a circular route either clockwise or anti-clockwise that took the visitor between the floors with unencumbered views and points of reference that informed them constantly where they going and where they had just been.

This then, was the glorious building that was finally unveiled to an eager public by Princess Louise, Duchess of Fife, on 2 May 1901, when the International Exhibition opened. The final cost of construction was the heady sum of £204,712, one shilling and sixpence. The excitement of a city hosting an international exhibition, in an era with very little mass entertainment, cannot be underestimated. Glaswegians thronged to the event, as did people from all over Scotland and beyond, and the money poured in.

The 1901 Exhibition

The exhibition took up 73 acres of Kelvingrove Park. And while the centrepiece, and of course the entire raison d'être for the whole event, was the new Palace of Arts, as it was referred to during the Exhibition, it was

dwarfed by the temporary Industrial Hall. This was an opulent oriental behemoth, designed by architect James Miller, the winner of an open competition to dream up this grand attraction (*see p.4*). Clustered around this crowd-pleasing fantasy, crowned by a golden angel holding an electric torch atop a grand dome, was a whole host of pavilions, concert halls, cafés and restaurants, and even an early example of a theme park ride in the shape of the Canadian Water Chute. This huge wooden slide catapulted customers in carts, for the price of sixpence, down the slide and into the River Kelvin. Needless to say this was one of the most popular attractions.

Such was the interest in the exhibition that the *Glasgow Evening Times* devoted a daily column to the gossip and events for its entire duration, entitled 'Under the Dome'. These entries are fascinating, not just for the precise details and complaints of the day, such as the amusing ongoing irritation at the Russian Pavilion's lack of lighting and surly attitude of those charged with its care, but as a subtle reminder of how sharp the class divide was in early twentieth-century Glasgow. This, for example, was how the customers attending on the Glasgow Fair holiday were described:

The crowd was mainly a paying one. In complexion it was quite different from what we have been accustomed with. It was distinctly a working class crowd. It came in family groups the stolid father ahead, with the mother dragging in the rear their plentiful progeny, and it spread itself all over the show.

Hard to imagine a modern journalist describing his fellow Glaswegians thus. Class even reared its head in a spat of correspondence in the *Glasgow Herald* in response to a plan to let working men and artisans in at the cheaper price of sixpence, instead of the normal entry fee of a shilling. After much disdain at the injustice of this, particularly from those who had purchased the expensive season ticket – plus the suggestion that it lowered the tone of the exhibition – a more sensible correspondent in the 31 August 1901 edition wrote, 'Let the classes and the masses meet together at Kelvingrove, and, believe me good will come of it'.

Although referring specifically to the exhibition, it would be pleasing to imagine that this was somehow prophetic of the way that the Art Gallery and Museum would be used and regarded for generations to come. In fact, it may well be argued that the egalitarian mix of the classes and of the educated and the illiterate set the tone for the inclusive and welcoming nature of this brand-new cultural facility that Glasgow had just been gifted.

Despite the myriad attractions on offer, there was little doubt that the star was the new Art Gallery and Museum, and the reviews were glowing. The *Art Journal* had this to say in October 1901:

The building itself, of which the architects are Mr John W Simpson and Mr J Millner Allen, is a magnificent contribution to the public buildings in Glasgow, and helps to redeem the commercial capital of Scotland from the charge of being unnecessarily prosaic. It continued: *The massive red sandstone of the permanent art galleries stands supreme, and dominates with proper gravity the semi-frivolity of the other erections in the exhibition grounds…and when all the white plaster has been cleared away, this beautiful building on the banks of the Kelvin will remain a splendid artistic addition to the city.*

When the exhibition finally closed its gates to the public on the King's birthday, Saturday 9 November 1901, more than eleven million people had attended. A substantial profit had been made and set aside for the future purchases of art and museum objects for the city, and the people of Glasgow had gained a magnificent building, whose structure and contents would inspire, delight, change lives and be cherished for generations to come.

...this beautiful building on the banks of the Kelvin will remain a splendid artistic addition to the city.

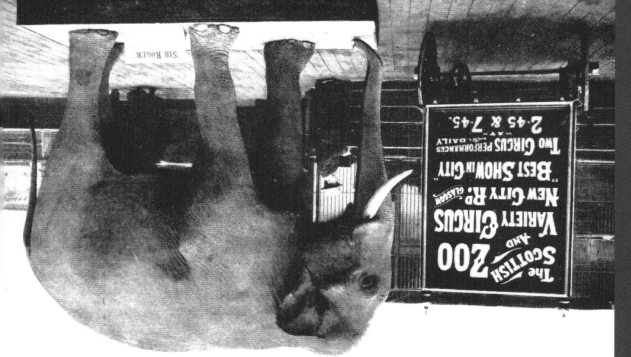

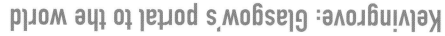

Kelvingrove: Glasgow's portal to the world

BUILDING THE COLLECTIONS

The life and times of Kelvingrove's collections would require a book the thickness of several house bricks, a course of literary action not open to this particular author. However, by casting a considerably more brief and random glance at what has happened over the last 100 years, we can still get a sense of what an exciting legacy the Kelvingrove New Century Project, charged with the recent restoration, inherited.

The Official Opening

Although the City now owned Archibald McLellan's art collection, the art section displayed in the brand-new Kelvingrove Art Gallery and Museum for the 1901 opening was not from the permanent collection, but on loan.

The City Council's intentions for the Exhibition had been: first, to introduce the new building to Glasgow's eager citizens in a grand and eventful style; second, to raise more funds for future collections. They also took the opportunity to display exhibits which specifically represented the culture of the nineteenth century and the past history of the Scottish nation.

The fine art, only in the building for the short six months of the Exhibition's duration, consisted of nineteenth-century oil paintings, watercolours and pastels, sculpture and architecture, decorative arts objects, works in black and white, objects relating to Scottish archaeology and history, and photography, a relatively new and exciting art form at the

time. The exhibition catalogue boasted that the collection was to be guarded at all times by the police and the fire brigade, and that the electric light, then such a novelty, had been installed as it was less hazardous than the gas lighting common at the time. This reassurance was understandable, given that the loans came from extremely high profile benefactors, including King Edward VII himself. The reaction of the crowds to this impressive collection, never before seen together in Glasgow, was one of overwhelming delight.

The permanent displays

At the conclusion of the Exhibition, the real work began in furnishing Kelvingrove with its permanent displays. The early part of 1902 was spent in the considerable task of returning the loaned exhibits to their owners. The Corporation Galleries, as the McLellan Galleries had been renamed, closed their doors on 20 September 1902, and the City's own collection was moved into its beautiful, purpose-built new home at Kelvingrove. The great organ, built by the London-based

Sculpture in the centre hall during the 1901 Exhibition.

Opposite: The magnificent Lewis and Co. organ, restored in the 1980s with support from the Friends of Glasgow Museums.

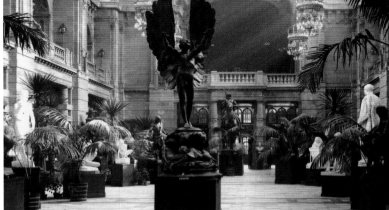

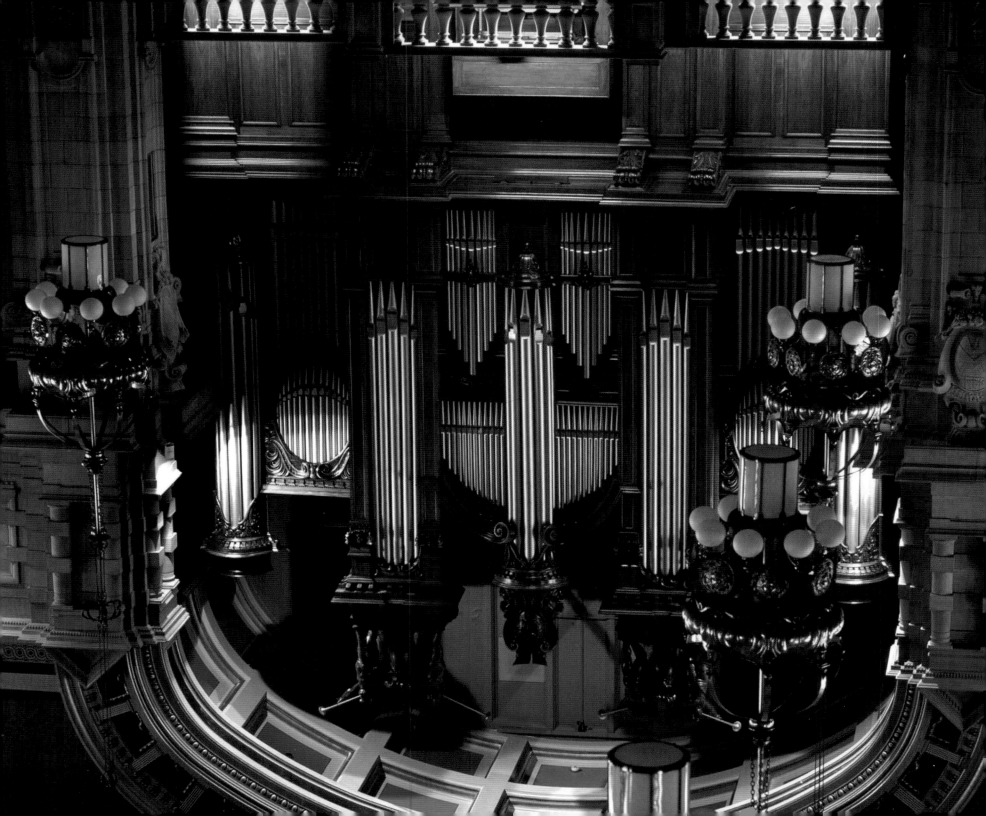

Some of the old displays.

company Lewis and Co., had been housed in a temporary concert hall for the duration of the 1901 Exhibition. It had entertained crowds under the skilful fingers of many renowned players, but was now moved into its permanent home at the north end of Kelvingrove's centre hall. Its ornate case was designed by the architects of the museum and, in keeping with the rest of the building, was no plain affair, boasting its fair share of trumpeting winged cherubs.

On 25 October 1902, the Lord Provost officially opened the building. There was a mind-bogglingly enormous guest list of 4,000 invited citizens, and that same evening the doors finally opened to the public. Admission was free, and the building was open daily from ten in the morning until nine thirty in the evening, with evening organ recitals provided twice a week. From that moment, the real love affair between Glaswegians and their magnificent new temple of culture could begin in earnest.

The layout of the collections

The collections from the City Industrial Museum and the fine art from the McLellan Galleries were finally united, and the decision was made to display them in three main sections – fine arts, industrial arts and natural history. Fine art was housed in the upstairs galleries, with the exception of sculpture, which crowded out the centre hall; the east wing dealt with natural history, and the west wing was devoted to technology and archaeology. It seems that this arrangement was clearly the most logical and convenient, since the museum more or less retained the essence of this initial plan, with only one or two significant changes, for the best part of 100 years.

The cases that had held the exhibits in the City Industrial Museum and the McLellan Galleries were judged to be in good enough order to carry on their work in the new museum. So, with the addition of cabinets

that had been built for the 1901 Exhibition, there was not a great deal to be done in the way of constructing new display cases. If this sounds rather piecemeal, especially considering the time, imagination and expense that had gone into the design of the building itself, it should be remembered that standard Victorian fashion was to lay out specimens to represent the structure of the subject. The model was natural history, with its system of kingdom, phylum, class, order, family, genus and species. All the showmanship at Kelvingrove was in the building itself, and as visitors today who knew the museum before its restoration will testify, the Victorians were quite content if one could simply see the object clearly without the razzmatazz of lighting and display techniques that modern audiences expect.

Now the building was formally open, and the collections were in place. The members of the Museum and Galleries Sub-Committee were eager, having ridden so high on the wave of international recognition that the 1901 Exhibition had brought, that they should not now be seen in any way parochial. To this end, they arranged for another loan exhibition to grace the building, this time a collection of works of art by French and British artists of the eighteenth century. The lenders

...a proud, permanent collection that could hold its own under international scrutiny

were no less distinguished than those who had furnished the 1901 Exhibition, and the works borrowed included paintings from the private collections of the Duke of Westminster and the Earl of Strathmore. This, then, set the tone early for Kelvingrove – a proud, permanent collection that could hold its own under international scrutiny, enlivened at regular intervals with temporary exhibitions, some more prestigious than others, but all with an eye to widening the cultural scope of Glasgow's cultural portfolio.

Adding to the collections

With all the hard graft of creating such a beautiful building behind, the task ahead was to fill it with collections that could live up to the expectations Kelvingrove had created. The 1901 Exhibition made a profit of £39,000, and it was intended that only the interest from this capital would fund purchases. Although this was a great deal of money in the early twentieth century, it doesn't require skill in maths to realize it could not have possibly funded the magnificent treasures that have been collected by the City over the last hundred years.

The mainstay of what we enjoy at Kelvingrove came from bequests, but purchasing has nevertheless played an

important role in keeping the collections coherent. Curators have been able to fill in gaps or take the collections in new directions rather than relying on the lucky dip nature of what they are gifted.

Portrait of Thomas Carlyle

Of course the most significant purchase was the McLellan collection, which kick-started everything, but other smaller purchases were important for different reasons. Glasgow Corporation were cautious buyers, but in 1891 a portrait of Thomas Carlyle by James McNeill Whistler (*pictured below*) came up for sale. A group of Glasgow artists, including James Guthrie, put such pressure on the

Kelvingrove's dinosaur -
Ceratosaurus (horned lizard).

Corporation to buy it that they capitulated.
This excellent decision (it was the first Whistler
in a public collection anywhere in the world)
was the start of a buying policy that reflected
a real commitment to giving Kelvingrove's art
collection a particular, and at the time quite
unique, personality. Purchases in other
departments, such as the David Corse Glen
collection of minerals in 1896, all helped to
set the tone for the constant maintenance of
a vibrant civic collection.

However, the very first purchases from
the 1901 Exhibition profits were modest
affairs. In 1902, the purse came out for a
plaster cast of Ghiberti's bronze doors from
Florence Cathedral at £50, and some Alaskan
ethnographic items for £120. A modest start
perhaps, but great things were to come.

The Natural History Collections

Over the last century, those visitors to
Kelvingrove with small children in tow would
doubtless all have experienced the impatient
tug towards the east court. What child could
resist the draw of Sir Roger the stuffed
elephant beckoning them into a magical
world of swooping birds, teeth-baring
predators and iridescent butterflies?

The natural history section of the
museum is magnificent testament to a happy
combination of the strict, and often obsessive,
Victorian ideals of collecting, preserving and
categorizing, with the modern ability to
interpret, analyse and entertain. The sheer
depth and variety of material, both on display
and in storage – where it remains available for
study and research – is quite staggering. It
contains internationally important collections,
such as the Robert Scase shells, the Manley
collection of moths and butterflies and the
John Young collection of Carboniferous Age
fossils. The collection boasts individual
treasures, such as the rare great auk, the
skeleton of a prehistoric giant Irish deer and a
complete *Ichthyosaur* fossil skeleton. It also
has, of course, the dazzling and dramatic
habitat displays of preserved birds, reptiles and
animals which have been presided over by Sir
Roger for so many years.

Sir Roger's story

Sir Roger is one of the museum's oldest and
most loved inhabitants, but the nature of his
journey from living, breathing pachyderm to
immobile exhibit is a sad one. Roger was an
Indian elephant brought to Glasgow in
Bostock and Wombell's travelling menagerie.
He was transferred to the Scottish Zoo in May
1897, an establishment no longer in existence
but at that time run by EH Bostock (*p.28*), a
menagerie owner turned zookeeper. Bostock
had a long and fruitful relationship with
Kelvingrove, and was responsible for the
supply of a great many of the best exotic
specimens. It seems that Roger fell prey to
musth, a hormonal condition common to male
elephants, and became highly aggressive and

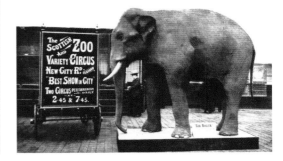

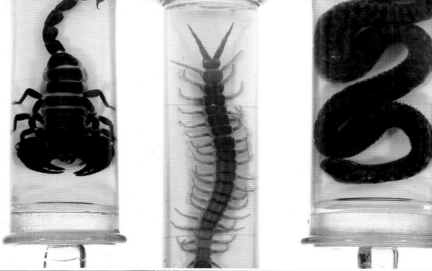
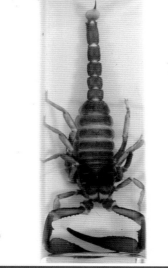

...a magical world of
swooping birds, teeth-baring
predators and iridescent
butterflies

dangerous. Bostock took the decision to call in a local gun shop owner. Rather peculiarly, he was in possession of an elephant gun, a curious piece of merchandise since the market for such an item in Glasgow must have been somewhat limited. With the back up of two local militiamen, Roger's life was cut short. The body was duly donated to the museum – one of the biggest specimens they had encountered yet – and mounted by the famous Glasgow taxidermist Charles Kirk. Being a menagerie animal, Roger's tusks had long since been removed for safety, so he was given two new wooden ones. The result, which we can see today, is one that still does the art of those early taxidermists proud.

Sir Roger momentarily looked a little less majestic in 2001, when in a stunt for Comic Relief's Pants for Poverty campaign to raise money for Africa, he donned a giant pair of red underpants. This temporary loss of dignity was deemed worth it for the £1,250 that went to the campaign.

Anyone seen my porpoise?

The collection of wildlife, whether stuffed animals, skeletons of vertebrates, insects, fossils or plant life, found its way into the museum by a great many routes, from the commonplace to the bizarre. The porpoise skeleton, for instance, was not donated by some benefactor or purchased from a keen cetacean collector. The fully fleshed animal was in fact found bundled up in a sack in the gents' toilets at Glasgow Central train station in the 1960s, and handed in to the museum when no one came forward to collect it. The image of someone sitting on a train suddenly wondering where they left their porpoise and eliciting the response from a fellow passenger of 'Don't you hate it when that happens?' is one that is hard to resist conjuring up.

Adding to the natural history collections

The collections in the natural history section used to be arranged taxonomically – the specimens were arranged in an order according to what was then believed to be their natural affinities. Given that curators had to try and do this with what they were given, from gents' toilets or otherwise, or what was on the market to buy, meant that collections may have had glaring omissions that rendered

Exotic specimens are, curiously, easier to come by than those creatures that surround us every day

the displays frustratingly incomplete. Staff often had to undertake fieldwork in the physical collection of specimens themselves, to help make sense of the material they already possessed. Although conservation is now absolutely at the forefront of Glasgow Museums' collecting policy, adhering as it does to all legislation introduced to protect our fragile environment, it was not always thus.

What's little known is that right up until the 1960s staff were permitted to go out and gather specimens by all kinds of means, including shooting them (under licence). This seems utterly bizarre now – that people we associate with careful preservation and the gentle art of field study would have gone marching over hill and dale blasting at things in order to stuff them and put them on

display. Although that policy was one that most will be glad is gone for good, the inability to collect at will nevertheless causes occasional curatorial problems. Exotic specimens are, curiously, easier to come by than those creatures that surround us every day. So while a deceased rare bird of prey would doubtless be handed in for identification and preservation, few people drop by with a dead sparrow or rat. Nevertheless, the animals in the wonderful display cases that delighted for years, commonplace creatures that we perhaps take for granted, were carefully collected over time, happily without suffocating squirrels or kicking pigeons to death. Previous visitors will probably best remember the tiny mouse eating the Jacob's cream cracker, but alas he hasn't made it back into the new displays.

TON AND A HALF OF BONE IN THIS WHALE'S HEAD 1919

Study and research

Specimens are not just collected for the purpose of dramatic and entertaining display, but also for comparative study and permanent record. While an exotic creature is of great interest, it's of equal importance to have a wide and representative group of more familiar creatures. To this end, the co-operation of the public has been invaluable. The department functions not only to advise on and provide public displays, but also to give advice and identify specimens for anyone who wants something mysterious given a name, or even simply to have its origin or purpose explained. The happy outcome of such a dialogue with the general populace is that very often, once the person has had their curiosity satisfied, they choose to leave the specimen with the museum, and so an interesting and varied collection builds up directly donated from engaged and enthusiastic individuals.

The sad tale of a budgie

On the subject of the public providing specimens, and grateful as the taxidermy section is for the enthusiasm of their fellow citizens, they occasionally have had to deal with people who seem a little confused over the museum's role. And nevermore so than when a lady brought in a live budgerigar with a broken leg requesting that the taxidermist fix it. Sympathy prevented him from turning her away so he took the bird to his workshop and carefully constructed a tiny splint. Unfortunately the taxidermist's art is performed only on creatures that lie perfectly still, and on attempting to cut the tape holding the splint, the budgie moved and the taxidermist's scissors cut the poor bird's leg clean off. With horror, he had no choice but to immediately put the bird out his misery. Strangely, when told the tragic news that her pet had died under the anaesthetic, the lady gratefully went home, never questioning what possible use a taxidermist would have for anaesthetic in the first place.

Kelvingrove's taxidermy department has always been amongst the best and busiest in the country, with staff struggling to keep up with the amount of specimens waiting to be treated. Even today, their giant freezer, situated in the Museum of Transport, contains birds and animals that were stored there as long as 40 years ago. Staff entering the freezer to search for some specimen were well used to the routine of climbing over the body of a huge tiger and greeting him like an old friend – parts of him are now on display.

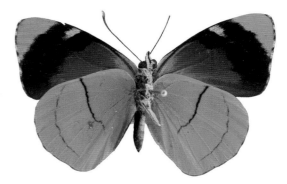

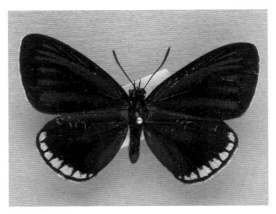

Those of us of a nervous disposition, however, would probably prefer not to imagine a trip into such a storeroom in the gloom of a dark evening, picking our way through a maze of teeth, claws and talons!

Of course there are a great many other ways of conserving the material that joins this magnificent collection. The use of casting and modelling in resins, foams and cold-setting rubbers is now widely used to enable soft, malleable creatures like frogs, fish and slugs to be preserved, and then displayed in a much more life-like manner than had they been preserved by more traditional methods. Alcohol preservation is important too, since it has become clearer over time that the soft tissue in species is often as important as other characteristics in making comparative studies. However, the practice that was adopted in the nineteenth century of preserving in Jamaican rum and Geneva gin, has been replaced by the use of industrial methylated spirits. One cannot say if this has come as a disappointment to those charged with the keeping and distribution of the preserving fluids, but if the temptation was ever there to supplement the staff Christmas party from the taxidermy supply cupboard, then that is something that has been forever removed.

The Collectors
WB Manley

The natural history collections have benefited from the generosity of great benefactors, and Glasgow Museums possesses some great and globally renowned collections. The Manley collection of butterflies and moths is one of the most extensive and diligently gathered groups of specimens in the country. It concentrates on Western Europe, where WB Manley and his wife travelled extensively on collecting trips for a great part of their lives. A large number of the specimens are from Spain, and many are illustrated in the book by Manley and HG Allcard, *Field Guide to the Butterflies and Burnets of Spain*. What marks the collection out is the meticulous way each specimen is set. Manley was a perfectionist, and not only is hardly an antenna or leg out of place, but each one is fully documented with date, locality and the altitude at which it was collected. It goes without saying that this makes it invaluable as a research tool across a great many other disciplines too. Although not bequeathed completely free, Manley's widow nevertheless sold the collection to Glasgow Museums for less than the value of the cabinets and drawers that contained the specimens. On the open market it's doubtful that the museum would have had the funds to compete with rival professional collectors, and so this act of generosity was greatly appreciated.

Robert Scase

Robert Scase's massive collection of molluscs was a bequest in the 1990s, and its importance cannot be underestimated. A private amateur collector, Scase worked in the Royal Botanic Gardens at Kew in London, but his interest in shells led to him amassing a carefully gathered selection from around the world, including some which are extremely rare.

The Tragic Strombus listeri

Given the museum's pride in its shell collection, a catastrophe that occurred in 1986 is all the more ironic. Kelvingrove was host to a temporary exhibition, *The History of Shell Collecting*. The majority of it was based on Glasgow's own collection, but it also included some important and rare specimens on loan, such as the *Strombus listeri*, one of the oldest known documented natural history specimens in the world. The excitement at having this unique shell in Kelvingrove must have been palpable. Quite naturally, such an exhibit deserved its own case, and once this was in place the shell was carefully mounted and gently positioned inside. The day before the

public opening, the final touches were being put to the exhibition, and workers on a scaffolding tower were hanging one of the graphics. Suddenly, the sign, which was very heavy, slipped and crashed into one of three cases, knocking them all down in a domino effect. The case containing the *Strombus listeri*, being in pride of place, was last to go. The shell tumbled out and was promptly crushed to pieces by the weight of the other cases – while the other shells remained completely intact.

One does not care to imagine the furore that such an accident must have caused, but the outcome was as unexpected as the accident was unwelcome. While the

fragments of the shell were being repaired, a small amount of sediment was discovered that revealed that this was not a live caught specimen – it had been collected as a dead, or empty, shell. Further analysis of the remains of the tiny animals inside provided new information on what part of the world the shell had originally come from – it had come from the Indo-Pacific region. Had the shell not been smashed, this important information might never have come to light. Good news indeed, but one wonders whether it was much consolation to the person who dropped the sign, and who even now probably finds it hard to fill up their car at a certain company's petrol stations without a shudder.

Anna Atkins cyanotypes

A near-catastrophe that would have eclipsed even the *Strombus listeri* affair happened in the 1980s. A member of staff, having a long overdue clearout of old storerooms, came across a number of musty boxes full of what looked like old photocopies. Being unidentified, they were deemed unimportant and set aside to be thrown out. It was only the sharp eye of another colleague that led to further investigation of the boxes, thus saving one of the department's flagship collections.

Ptilota sericea.

For these were the photograms of Anna Atkins, and their value now is incalculable. Atkins was a remarkable person, part of a select group of pioneering British photographers in the early nineteenth century that included famous men like William Henry Fox Talbot and Sir John Herschel. Her passion was collecting and recording algae and seaweeds, which she did tirelessly and comprehensively, laying her specimens on specially prepared photographic paper and exposing them to strong light to make perfect detailed silhouettes of each one. This process is what we now call a blueprint, and the result was a series of images that not only serve a scientific purpose, but are also delicate and beautiful works with an aesthetic appeal far beyond their intended purpose. The diligence and tenacity with which Atkins addressed her work was all the more remarkable when we consider how difficult it must have been to pursue such a passion as a female, in an era when the act of devoting oneself to work or study was considered at best unsuitable for, and at worst completely out of bounds to, women. It's this added aspect that contributes to the special regard in which these works are held, and the relief that they have been saved to be appreciated by thousands, instead of rotting in a bin.

Buying for the Collections

Although bequests have been the mainstay of the collection, purchases have been important too. For example, the purchase of the David Corse Glen collection of minerals and fossils in 1896, some 6,700 specimens in total, was an absolutely invaluable addition. But it wasn't just these voluminous collections that mattered to curators. In the early 1900s, the City was offered a stuffed specimen of the extinct great auk. This flightless bird disappeared from the earth in 1844, having last nested on Eldey Island in Iceland. The specimen had been on loan from Lord Malcolm of Poltalloch in 1902, but when it was offered for sale at around £25, for reasons best know to themselves the Museum and Galleries Sub-Committee declined the offer. It was to be nearly 90 years before they had a second chance. Another great auk had been on loan from Michael Pilkington, who had bought it from Durham University. It was finally offered for sale, and this time the chance was taken up with enthusiasm, although the asking price for this one was an eyebrow-raising £30,000. Despite the hefty price, the specimen was felt to be well worth it. The great auk is now a central part of the collection, giving visitors not just a chance to examine this extinct creature in its full, life-like

Pupils from Glasgow schools designed tiles which now decorate the corridor of the Education Suite in Kelvingrove.

plumage, but also to contemplate the part played by humans in the circumstances that led to its extinction.

The department has organized and hosted many interesting temporary exhibitions, including the hugely popular *Claws*, a celebration of all things feline, from the humble tabby to the tiger, but it also witnessed a most peculiar one. In the 1950s a macabre travelling exhibit, Jonah the Whale, toured the country. This was a 58-ton blue whale caught off Trondheim in Norway, which had had its guts removed, lungs inflated, and a refrigeration unit placed inside it. It came to Kelvingrove on the back of what was at the time the longest lorry in the world, at 100 feet. It was parked outside the building, and paying visitors could walk right through the luckless mammal. Its popularity was

enormous, but were those who queued for hours there out of a genuine interest in natural history, or were they giving in to that more base nature that likes to gawp at a sideshow freak? However, Kelvingrove staff were rewarded by the fact that many of these paying customers were sufficiently beguiled enough by the whale to venture into the museum to see what else was on display, and visitor numbers went up. Maybe the thrill-seekers ended up learning something after all.

From humble beginnings in the City Industrial Museum in Kelvingrove Mansion back in the nineteenth century, right up to the magnificent restoration in 2006, the natural history department's collection has grown into a treasure worthy of the international status it enjoys. We are all enriched by it.

THE ART GALLERIES

Kelvingrove: Glasgow's portal to the world

Despite Kelvingrove's formal title of 'Art Gallery and Museum', Glaswegians have almost always referred to the building simply as 'the Art Galleries'. This is even more curious when we know that two thirds of visitors never got to the first floor to view the art at all. Perhaps it's a subliminal reference to the fact that it was Archibald McLellan's bequest of paintings in 1854 that inspired the whole idea of Glasgow possessing its own important civic collection, and the 'art bit' just stuck. Whatever the reason, the art collection in Kelvingrove may have grown to be one of the most important in the country, outside London, but the emotional and intellectual effects it has had on generations of Glaswegians, this one included, far outweigh any formal appraisal of its academic status in the curatorial world.

When Kelvingrove opened in 1902, the City owned 850 oil paintings, about 200 watercolours and drawings, very few prints, and 75 sculptures. The current collection now runs to over 3,000 oil paintings, 10,000 prints, 2,500 watercolours and drawings and 300 pieces of sculpture – a solid indication that in terms of expansion there has been no loss of commitment to the city fathers' initial intention.

How the art collections have grown

Generous and wealthy benefactors gifted the majority of the art, but purchases have been made through the years using various sources, including the profits from the 1901 Exhibition. The Hamilton Bequest is one of these sources. John Hamilton, the founder of the Bequest, was a storekeeper who lived in Pollokshields, but had old family connections with the Kelvingrove area. When his sisters died in 1927, under the terms of the Bequest the Trustees began to buy pictures specifically for display in Kelvingrove. Since then, the Bequest has contributed to the purchase of many important works, such as some of the French Impressionist paintings, and the acquisition in 2006 of Stephen Conroy's *Self-Portrait*.

What marks the collection out, however, is that it is not the artistic hotchpotch one might expect from inheriting the taste of a random bunch of millionaires, but rather it has been constructed with remarkable care. This is mostly due to the skill, knowledge and passion of the curators over the last 100 years, but also to the fact that private collectors in late nineteenth- and early twentieth-century Glasgow were people who knew precisely what they were doing.

The collectors and dealers

Individuals, made newly wealthy by Glasgow's booming industrial success, were keen to be accepted by polite society, particularly if they had come from humble beginnings. Being regarded as an art lover gave the industrialist or the shipbuilder a certain amount of social acceptance which leapfrogged class, and the

The current collection now runs to over 3,000 oil paintings, 10,000 prints, 2,500 watercolours and drawings and 300 pieces of sculpture

Opposite: View of Ventimiglia by Claude Monet, an outstanding gift from the Hamilton Bequest.

fact that this was greedily sought at the time cannot be underestimated. Art dealers, who recognized this new and lucrative market, opened up in Glasgow and the great private collections began to be amassed. Happily, despite a great deal of this purchasing happening simultaneously, there was very little duplication in these collections, doubtless because of the professionalism of the dealers. What's more, from conservative starts, with collectors unsure of their taste buying 'safe' landscapes and animal portraiture, confidence built up under the educating and enlightening influence of dealers such as Alexander Reid, until Glasgow collectors were largely buying what took their fancy and pleased their eye. That leap of imagination that widened the buyers' artistic appreciation was one of the factors that made these collections so valuable when they ended up together as the property of the City.

The bequests

The bequests of the last 100 years are too numerous to list in full, but there are milestones which deserve to be highlighted. William Euing followed Archibald McLellan's pioneering gift to the City with a bequest in 1874 of over 100 pictures, mostly Old

Masters. Three years later the widow of painter John Graham-Gilbert bequeathed his collection of 70 paintings – this included Kelvingrove's most valuable and treasured work, Rembrandt's *A Man in Armour*. Sir William Burrell, undoubtedly the most famous and greatest collector and benefactor Glasgow has produced, deserves a mention in passing, since selected parts of his collection came temporarily out of storage and have appeared intermittently in Kelvingrove since the 1920s. However, since Burrell's gift was never destined for Kelvingrove, but always intended to be viewed and housed as one collection in its own building, we must leave the details of his gift to Glasgow to other publications.

The bequest from James Donald in 1905 of nineteenth-century Dutch, French and British oil paintings and watercolours set the foundation for Kelvingrove's French Impressionist collection. This was consolidated in 1944 by the enormously important bequest from Glasgow ship owner William McInnes. His collection of paintings, prints, drawings, silver ceramics and glass included 33 French works, many of them bought from Alexander Reid, whose influence on the whole Scottish art scene was so pronounced. These included major works

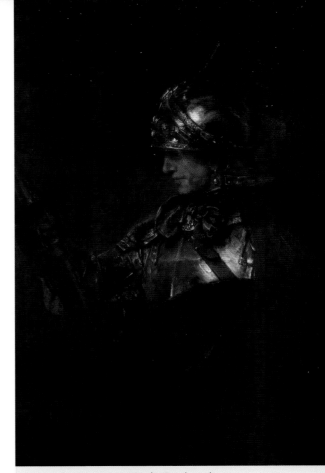

A Man in Armour, c 1655, by Rembrandt.

The 'Man in Armour' comes home

Express Staff Reporter

GLASGOW'S masterpiece paintings, hidden safely away in country districts since the start of war, are coming home again to the walls of the Art Galleries, Kelvingrove. 1945

by artists such as Picasso, Monet, Van Gogh, Cézanne and Degas, and also importantly, paintings by the Glasgow Boys and the Scottish Colourists whose regular patron and friend he was.

Following World War II, bequests and major gifts became increasingly rare. The days of the grand collector and benefactor were over, partly because the international market had become a serious field of investment where such collections could fetch previously unimagined prices, partly because family firms were replaced by corporations with shareholders, and partly because the ways in which the wealthy elevated their status in society had changed considerably. Great wealth no longer automatically demanded the civic duty of the past, and both dealers and collectors drifted south and abroad to capitalize on this new international market.

Kelvingrove, therefore, had to fill the gaps in its collections and keep its progressive eye keen by purchasing. This buying, done over the years with careful consideration and enthusiasm (although not without the occasional controversy), was always significant.

The Art Fund

The Art Fund, previously the National Art Collections Fund, has been a stalwart supporter of acquisitions for Kelvingrove since its foundation in 1903. This charitable organization's sole purpose is to support museums in acquiring important works of art. The Fund has supported Glasgow Museums in purchasing over 300 objects, including Van Gogh's *Portrait of Alexander Reid*, the Hill House writing desk by Charles Rennie Mackintosh (at nearly £1 million the most expensive piece of modern furniture), Faed's *The Last of the Clan* and most recently, Stephen Conroy's *Self-Portrait*.

Alexander Reid

One of the pictures central to the story of Glasgow's French Impressionists collection was Van Gogh's *Portrait of Alexander Reid*. Reid, one of the most important art dealers in Glasgow, was a man far ahead of his time in his appreciation of the innovative French movements in art. It seems that his role in educating his clients to understand this new art was pivotal in Glasgow being ahead of the game in its appreciation and acquisition of important nineteenth-century French art. Reid travelled extensively in France, and spoke the language fluently. His connection with Vincent van Gogh was particularly intimate, having met him through Vincent's brother Theo. In 1887, Reid briefly shared a room in Montmartre with

Portrait of Alexander Reid, 1887, by Vincent Van Gogh.

£87,500 grant to buy Van Gogh

Glasgow Art Gallery is to get an £87,500 Government grant towards the cost of a Van Gogh masterpiece. 1974

Vincent – Reid having fallen out with his girlfriend and Van Gogh being characteristically flat broke. This relationship came to an abrupt end when Reid unburdened his woes to his roommate, and instead of buying him a companionable drink, Van Gogh suggested they both enter a suicide pact. Despite Reid's reluctance to die young, Van Gogh nevertheless painted two pictures of him. The head and shoulders portrait bought in 1974 for the bargain price of £166,250 – kept this low by the seller, Reid's grandson, as a mark of affection for Kelvingrove – is an important part of Glasgow's history as well as an exquisite work of art.

The Dali

One of the most controversial purchases was initiated by Dr Tom Honeyman, or TJ as he was known. Honeyman was perhaps one of the most memorable and influential directors Glasgow Museums ever employed. His background in art dealing had given him an open-minded approach to art appreciation, much in the mould of Reid before him. Though some thought him a 'wild card', when it came to guiding Kelvingrove's collections his choices have mostly stood the test of time, none more so than the purchase of Salvador Dali's *Christ of St John of the Cross*.

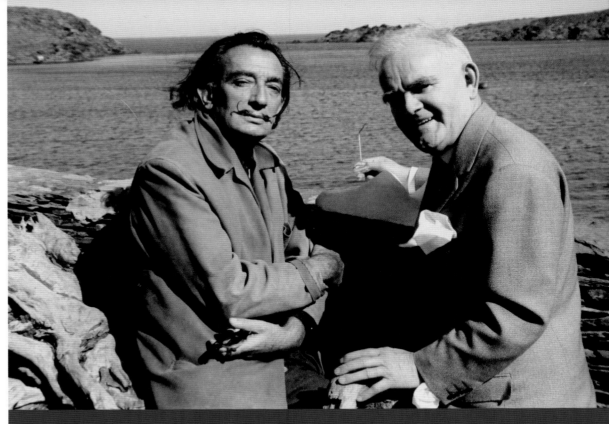

Honeyman visits Dali at his home in Port Lligat, Spain - the backdrop to his famous painting of Christ.

Honeyman was perhaps one of the most memorable and influential directors

Honeyman saw the picture for sale at the Lefevre Gallery in London in 1951, and was convinced that it was a picture that Glasgow must have. Because of his personal contacts with both the owners of the Lefevre and Dali's agent Georges Keller, Honeyman had the painting sent up to Glasgow for consideration, and convinced Glasgow Corporation and his curators that it was worth the money. Although the catalogue price was £12,000, Honeyman used his connections and undoubted charm and beat this down to £8,200, which just happened to be the last pennies left from the profits in the 1901 Exhibition Fund. In addition, he secured the copyright to the image from the artist, which was (and is) often difficult to do.

But instead of Honeyman being carried shoulder high in victory at this coup, there was an instant outcry from almost every quarter. The art establishment regarded Dali's super-realism and uncharacteristic choice of subject as ephemeral, cynical, and lacking any depth or meaning. Students at Glasgow School of Art protested that the cash should have been spent on more young local artists. Some members of the public, whipped into a frenzy by the ever-mischievous press and confused in their understanding of which public purse the money had been taken from,

expressed outrage that the money was not being spent on good causes. Even highly esteemed artists such as Augustus John called the purchase a 'mad extravagance', and deplored the 'mad price' being paid to a living painter. Honeyman's logical response was to ask, 'Why do they not rejoice that, for once, the artist rather than his descendants reaps the benefits from his labour?'.

TJ, however, was proved not only right, but also spectacularly astute. The public flocked to see the painting, contributing massively to the art fund via a box placed beneath the picture for visitors' sixpences. Such is the polarized emotional response that visitors experience when viewing the painting that it has been attacked twice: once when a man punctured the canvas with a sharp stone and then ripped it with his hands, and once with an air gun which dented the perspex by then protecting it. However, Kelvingrove conservators expertly repaired the damage, and the non-professional eye would now find it hard to spot the wounds. In 1993 the painting was moved to St Mungo Museum of Religious Life and Art, but many thought this a mistake, and its return to its old spot in the restored Kelvingrove will delight thousands of visitors.

Christ of St John of the Cross, 1951, by Salvador Dali.

VE Day, 1945, by LS Lowry.

Other notable purchases

Some other notable purchases include Faed's sentimental but beguiling *The Last of The Clan* in 1980 (*pictured above*), Jules Breton's classically inspired *The Reapers* in 1984 (*detail opposite*), and Joan Eardley's haunting *Two Children* in 1994. This painting was on Eardley's easel when she died, and although there were other of her works already in the collection, this one is possibly the best. In keeping with the desire to monitor and reflect all that is excellent in contemporary Scottish art, the purchase of Stephen Conroy's *Self-Portrait* in 2006 was a fitting mark of a new century of painting, celebrating as it does the persistent power of figurative painting in the face of conceptual art.

Lost and Found – Lowry's VE Day

As with any large institution, there have been triumphs, disasters and near catastrophes at Kelvingrove as long as it has been open. In 1992, during an evening charity dinner for 300 people, a sneak thief managed to cut the canvas of the Lowry painting *VE Day* clean from its frame with a sharp knife, roll it up, hide it under his clothing and escape. Luckily for everyone, he was hardly out of the mould of glamorous, sophisticated and cunning art thieves, but in fact was an utter idiot, obviously unaware of the virtual impossibility of selling a well-known painting. This fortunate absence of guile led to the discovery of the canvas in the back of a car six months later and its return to Kelvingrove relatively unharmed. Security since then has been constantly under review, and the chances of anyone leaving the building these days with anything that is not their own are about the same as Scotland winning the World Cup!

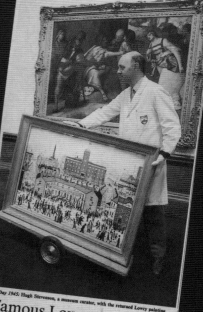

VE Day 1945: Hugh Stevenson, a museum curator, with the returned Lowry painting

Famous Lowry which was stolen goes back on show

By Iain Duff

WITH the minimum of fuss, one of Glasgow's most famous paintings was yesterday put back on show after almost 20 months lost to the public view.

The painting, LS Lowry's *VE Day 1945*, was stolen in March 1992 during a charity function at Kelvingrove Art Gallery.

It was recovered six months later in the back seat of a car in Edinburgh and since then has been held as evidence for a court case followed by extensive repair work by restoration experts at Kelvingrove.

Yesterday the 3ft 6in by 3ft painting, valued about £200,000, was rehung in the Realist Tradition of Art gallery on the upper floor.

A Kelvingrove spokesman, Vincent Teggart, explained that the painting, bought by Glasgow in 1945, had suffered about £800 damage.

"The canvas was removed from its frame and it had been folded like a map. After the painting was recovered we couldn't touch it for several months because it was at least of evidence in a pending court case."

After the case, experts from Kelvingrove's team of restorers repaired cracks in the canvas and touched up areas of paint.

In October, John Forbes, 30, an unemployed property manager of Wheatfield Street, Gorgie, Edinburgh, was jailed for 18 months at the High Court in Edinburgh for resetting the painting, one of Lowry's most famous works.

The painting had been found sandwiched between two large sheets of cardboard in the back of Forbes's car. Forbes claimed he knew nothing about it and that the car had been loaned to a friend earlier in the day.

Clockwise from top left, details of:

A Mediterranean Port 1892, by Arthur Melville

The Young Girls, c.1885, by Mary Cassatt

The Fairy Raid, Carrying off a Changeling - Midsummer Eve 1867, by Sir Joseph Noel Paton

The Reapers, 1860, by Jules Breton

Japanese Lady with a Fan, 1894 by George Henry

On with his head!

The painting of *The Adulteress brought before Christ*, once attributed to Giorgione and now thought to be by Titian, is one of the most valuable paintings in the collection. Conservators had restored it to its full vibrant colouring in the 1950s at the command of TJ Honeyman, another decision that was deemed controversial at the time. However, even though it had been restored, the painting was still not as it had been originally executed – a figure had been missing from the painting for many years before its arrival at Kelvingrove. In the past it was occasionally the fate of paintings to be cut up, usually to make them fit a wall or frame. The attitude to art was often that it was a symbol of the owner's status or mere decoration, rather than being revered for its artistic merit. In this case, a figure of a man had been sliced from the adulteress's side, and there was understandable excitement when the head of this missing figure came up for auction in 1971. Funds were quickly sought and granted, and to everyone's delight Kelvingrove's bid was successful. The head (*pictured right*) is now displayed in its own frame next to the main picture, and there are few curators who would deny that they dream of being the one who will someday find the missing legs.

The Adulteress brought before Christ, c.1508–1510, by Titian.

Prints, drawings and watercolours

Whilst oil painting is a tour de force at Kelvingrove, prints, drawings and watercolours are no less well represented. The print room was set up in 1922, when interest in prints was enjoying a major boom in Britain, and the collection now boasts over 10,000 prints and 2,500 watercolours and drawings. British, and most particularly Scottish, works form the largest and most comprehensive section of the collection, so, in addition to some highly

A Mediterranean Port, 1892, by Arthur Melville.

The sculpture collection

The 1901 visitor would have been introduced to art in the shape of sculpture as soon as they entered the building – and to lots of it. The centre hall was crammed full of plaster casts and large marbles, arranged in a 'palm court' fashion, and it largely stayed this way until calamity struck. On 13 March 1941, the Germans launched a blitz on Clydebank and the results were catastrophic. Compared to the loss of life – 528 people killed and 600 injured – the destruction of 4,000 homes was of course of secondary importance, but amongst this havoc Kelvingrove did not go entirely unscathed. A landmine fell from the sky and exploded on the banks of the River Kelvin, blowing out almost every piece of glass in the art gallery and museum, and causing extensive damage.

TJ Honeyman used the clear up as an opportunity to alter the centre hall display. It had displeased him for some time, and he described it as 'an eye sore, with so many pieces of bad sculpture and plaster casts dotted around like men on a chess board'. Instead of confining the sculpture to the obscurity of storage, Honeyman arranged for the pieces he thought of little artistic or historical value to be moved to the Kibble Palace in Glasgow's Botanic Gardens. These

important Old Masters and outstanding nineteenth-century French and Dutch works, there are stunning examples from the very finest British artists from the turn of the century.

The Glasgow Boys are well represented, with Arthur Melville and Joseph Crawhall standing as examples of superb watercolour mastery. The landscapes by arguably Glasgow's most famous son, Charles Rennie

Mackintosh, are amongst the genuine treasures to be found in the collection. If visitors are less familiar with individual works from the print room collection than they might otherwise be, it's most likely because of the delicacy of the media. They are extremely light sensitive, and this means that exhibits can't be displayed for any great length of time before they must be returned to the security of a dark, humidity controlled store.

statues are now much more highly valued and were recently conserved by Glasgow Museums' staff as part of the refurbishment of the Kibble Palace.

Changing Tastes

Tastes change, and the current collection now stands at over 300 works, covering the period from the late eighteenth century to the present day. These are mostly of the British School, and include some outstanding examples of the movement that was known as the 'New Sculpture' of the 1880s. This was a group of artists,

Motherless, c.1889, by George Lawson.

including Frampton and Derwent Wood, who made a return to the values of the Renaissance in a move to distance themselves from the sentimentality of the Victorian era. This did not necessarily mean abandoning the strong narrative tradition that had gone before, but there was a more muscular drama to their subject matter, and an enlivening of the surface texture of the stone was often used in heightening this tension. *Isaac and Esau* by E Roscoe Mullins – the massive marble that until recently survived the great centre hall clearout to hold sway between the doors at the north entrance – is a good example of this period.

The large number of late Edwardian and Victorian pieces in the collection is telling, reflecting how Glasgow's commercial expansion at the time attracted the country's best sculptors to embellish the results of the accompanying building boom. As well as works that have captured the hearts and imaginations of visitors over the years, such as George Lawson's sentimental but heartbreaking *Motherless*, there are works of outstanding significance. John Flaxman's two-metre high marble figure of William Pitt is acknowledged as an example of an artist at the height of his skills. The French School, though considerably smaller, nevertheless

contains exquisite delights in the form of bronzes by Degas, Rodin and Renoir. The momentum to collect contemporary artists was never lost, and representing the later twentieth century period are works by Edinburgh's Eduardo Paolozzi, the Russian sculptor Ossip Zadkine and England's Anthony Caro.

Made to Fit

One piece of contemporary sculpture that proved a display headache for the curators was the massive two and half ton marble work by a Scottish artist, the late Ian Hamilton Finlay. The work, entitled *Clay the Life*, was bought in 1991, but when it came to display it on a staircase wall, it was clear that it would never fit. Instead of abandoning the work to a less suitable place, or even worse, into storage, the artist's collaborator Nicholas Sloan was forced to chip a piece off the back to make it fit. One wonders if Michelangelo would have been so cooperative in a similar situation and if so, which piece of David he might have sacrificed?

Left: *Syrinx,* 1925, by William McMillan.

Stirring Passions

Over the years the sculptures have inspired a great many different responses from visitors, but quite what emotion the statue *Syrinx* ignited in a young lady visitor and her boyfriend in 1991 remains a mystery. Before anyone could react, the young woman stripped off and was photographed next to the statue by her willing companion. By the time security were alerted by startled onlookers, she had made her way to the tearoom, fully clothed, for a spot of refreshment. We will never know whether or not the sculptor approved of this unusual appreciation of his work, but we can categorically say that the security staff did not.

Another work appeared to stir peculiar sexual awakenings in its audience. Rodin's *Age of Bronze* had its penis stroked by so many visitors that the bronze patina wore off. Culprits, caught in the act and asked to desist, explained that it was 'for luck', but since the majority of the guilty were generally women we must draw our own conclusions. The bronze has been restored to its glory and is now at the Burrell Collection.

Sculpture continues to hold an honourable place in Kelvingrove, and given that contemporary figurative sculpture, with a very few notable exceptions, is almost a dead discipline in the twenty-first century, it makes the collection even more important. Here at least there is still opportunity to appraise and appreciate the last century's efforts in that miracle of capturing the animate, dynamic and abstract in cold, hard materials.

The Decorative Arts

Those who dismiss the decorative arts as the poor sister to painting and sculpture are making a grave error. Many of the world's finest artists across the centuries have expressed themselves in the design or embellishment of everyday objects. And while nobody would argue that the complex profundities of the human condition are best explored in a spoon, it is nevertheless true that the artistic endeavours lavished on objects through time tell us a great deal about humanity.

To this end, the Kelvingrove collection contains objects that are not just works of art, but also vital pieces of social history. The collection encompasses a huge range of material, including ceramics, glass and silverware, jewellery, costume and textiles, and furniture.

The Collectors

Much of this collecting had begun in earnest prior to the 1901 opening. The decorative arts were a prime feature of the City Industrial Museum, and a large proportion of the local work in glass, silver and ceramics can be traced back to collectors who had contributed to the City's collection from the very

Lewis Lyons (1905–1999) a generous donor of Scottish silver and Old Masters drawings.

beginning. There was Victor J Cumming, shipping agent, who gave the core of the Scottish silver collection, and his mother, who left a magnificent bequest of English ceramics. Miss J Fleming, whose father J Arnold Fleming wrote the basic textbook on Scottish ceramics, gifted a collection of these. And Lewis Lyons, Glasgow businessman and silver dealer, who bequeathed a marvellous collection of eighteenth-century silver, including tea and coffee pots, ladles and spoons by Glasgow silversmiths. There is such a bewildering variety of work in this section of the collection that we can only dwell on the items that most would agree are part of the very fabric of Kelvingrove's unique personality.

The Thomas Lipton Bequest

Thomas Lipton, the millionaire grocer and keen competitive sailor, was a native of Glasgow, and in 1937 he bequeathed his entire collection of presentation plate and sailing trophies. These elaborate cups, plates, punch bowls and vases speak of a time of opulence and excess, and the workmanship is of the finest quality.

Seton Murray Thomson

Almost all child visitors remember the focus of Seton Murray Thomson's interest. He was a wealthy benefactor, obsessed by collecting images of horses, in any form. This collection of 449 items was gathered between the years of 1923 and 1933, comes from 19 different countries, and is made of over 30 materials. It was the broad and almost undiscerning nature of his purchasing that makes this eccentric collection so intriguing. While it contains supremely valuable items, such as a sixth-century Greek ceramic horse and rider and a similar ancient Chinese earthenware, it also has model horses purchased from Woolworths. The variety of horses delighted children for years at Kelvingrove, and given the huge variety of material that Thomson had to choose from, his passion highlights that it was one that was shared through the ages from ancient times onwards.

Ceramics and glass

Ceramics and glassware are well represented, including centuries-old drinking vessels that now look surprisingly modern, given the current return to ornate dining. There are fine collections of eighteenth- and nineteenth-century vessel glass, from donors such as Miss JCC Macdonald, Miss Louise C Walton and Mrs John Baird's gift of examples from the John Baird Glass Works of Glasgow.

Displaying items as delicate as glass can be problematic, but it caused great relief at Kelvingrove that a classic piece of clumsiness was not perpetrated by a member of staff but by a representative of the owner of a collection of glass lent for a temporary exhibition. Asking to place one of the more precious eighteenth-century glasses on its stand himself for extra safety, the gentleman did so with great care and purpose. Sadly, he had not realized, as he thrust the glass forward into position, that the glass case in front of him, polished so beautifully that it was barely visible, was closed instead of open. Object handling is probably best left to the professionals…

LIPTON TROPHIES ARRIVE IN GLASGOW

Mr James Eggleton, F.S.A.(Scot.), director of Glasgow Art Galleries, superintending the unpacking of the Sir Thomas Lipton yachting trophies bequeathed to Glasgow on their arrival at the Galleries yesterday. The gold cups seen are (l. to r.) the King's Cup, the Royal Albert Cup, the Bristol Channel Cup, and the cup presented by American citizens to "the world's gamest loser."—"Bulletin" Photograph.

Clockwise from top left: detail from an English gown in cream silk brocade, about 1780; Maiolica plate showing Apollo and Daphne, c.1535, by Francesco Xanto Avelli; clay horse and rider, 6th century BC; detail from cloak found in the Summer Palace, Beijing 1873

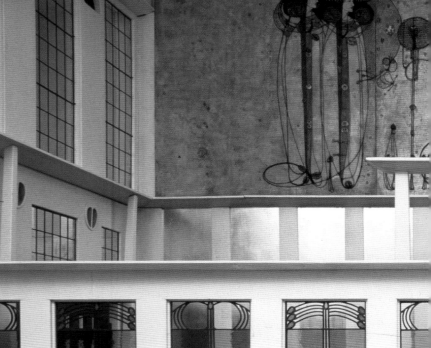

Charles Rennie Mackintosh

A considerable amount of Charles Rennie Mackintosh material was, until the 1970s, virtually unseen by the public. Although there were significant objects in the collection, they were only occasionally displayed, and in fact, the chair for the Mackintosh writing desk was used as a prop for the costume displays rather than displayed as a design piece in its own right. Glasgow Museums had acquired almost all the Ingram Street Tearooms interiors, designed by Mackintosh for Miss Cranston, when they were dismantled in 1971, as well as some of the furnishings and detailed fittings. These languished in storage year upon year. Storing so many objects, many of them very large, presents special problems, and it was difficult to find a building that combined enough space with suitable environmental conditions.

It might seem utterly ridiculous to the modern mind, but there was a feeling amongst many Glasgow art experts that Mackintosh was perhaps a little parochial, and not of any great significance in comparison to some of his international contemporaries. It was only when he was 'rediscovered' in the 1960s that the revival began in earnest. The clean and elegant lines of Mackintosh's unique style started to be appreciated for the revolution in design that they so clearly were, and those who were opposed to giving his work prominence had a welcome change of heart.

Throughout the 1970s the Glasgow Style collection was added to, and there were small displays of tearoom furnishings and Glasgow Style furniture. The 1980s and 90s brought the milestone exhibitions *The Glasgow Style 1890–1920* – the first major exhibition covering the wealth of work produced by Mackintosh and his Glasgow contemporaries – *The Glasgow Girls, Women in Art and Design 1880–1920*, and a three-venue tour in North America of a major exhibition of the work of Charles Rennie Mackintosh.

A massive restoration project of the tearooms was undertaken, and is still

ongoing, funded by the Heritage Lottery Fund and Donald and Jeanne Kahn. Visitors will see some of the results in the new Glasgow Style gallery, given absolute pride of place in the new restored Kelvingrove.

A massive restoration project of the tearooms was undertaken, and is still ongoing.

Above left: Charles Rennie Mackintosh writing desk for the Hill House, jointly owned by Glasgow Museums and The National Trust for Scotland.

Above: Detail from the restored Ladies' Luncheon Room, showing *The Wassail* gesso panel.

The Hull Grundy Gift

Another part of the collection that a great many people recall as a highlight from the 1970s onwards is the huge jewellery collection gifted by Mrs Anne Hull Grundy (*pictured below*). Between 1976 and 1984, Mrs Hull Grundy collected and donated over 1,200 pieces of jewellery of all kinds, both precious and costume. The pieces range from the early eighteenth century to the 1930s and include not just British work, but items from all over the world. Mrs Hull Grundy was by all accounts an eccentric figure, who lived bedridden in Chilbolton in Surrey. She made a number of gifts of jewellery to British museums, but decided to gift Glasgow's collection on the advice of her Scottish nurse, who told her that Kelvingrove was without any significant collection and deserved to have one. The gift was unusual – it was delivered as she collected, new pieces arriving regularly at Kelvingrove wrapped in used, round sweetie tins. Mrs Hull Grundy demanded acknowledgment of receipt on the day of delivery or she became extremely cross, and curators were rigorous in meeting her demands. The artistic content and social history that is evident in her meticulously and intelligently gathered collection is incredibly

valuable to the museum. And whilst visitors through the decades have doubtless been grateful to Mrs Hull Grundy for her passion and generosity, we Glaswegians should not forget the canny nurse.

The furniture, cutlery and ceramics that are also part of this dazzling collection have intrigued visitors for years. Doubtless their new place in Kelvingrove, where they are interpreted in a wider context, will draw an entirely new audience into the appreciation of craftsmanship and design.

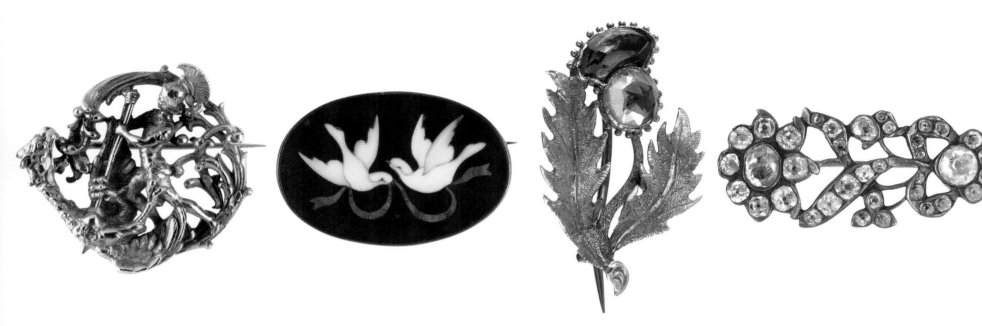

French brooch cast in gold, showing St George slaying the dragon, mid 19th century.

Italian brooch with image of pair of flying doves in Florentine mosaic, cut stone in gold setting, mid 19th century.

English brooch in enamelled gold, about 1820.

English jewellery section of pastes in a foiled silver setting, about 1780; made into a brooch at a later date.

English insect brooch made of
mirrored glass and brass, early
19th century.

French brooch of gothic
openwork motif pattern
cast in gold, by Jules
Wiese, about 1860.

Scottish corsage brooch with
winged dragon motif in enamelled
gold set with semi-precious
gemstones, designed and made by
James Cromar Watt, about 1910.

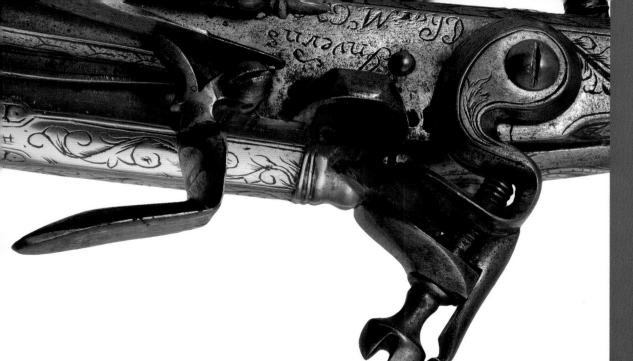

HUMAN HISTORY AND TECHNOLOGY

Kelvingrove: Glasgow's portal to the world

Technology

Like almost everything in the modern world, museums and galleries are becoming ever more specialized. It's interesting then to remember just how broad-based the collection used to be at Kelvingrove, before sections of it such as technology, religious objects and modern art were dispatched to their new homes at the Museum of Transport, St Mungo Museum of Religious Life and Art, and the Gallery of Modern Art. The heady days when everything was still together in Kelvingrove did not, however, mean a confused mess, but simply represented the wide spectrum of interests that the public expected to see reflected in the collection. Technology, for instance, had no shame in sitting side by side with fine art.

James Watt's beam engine

The City Industrial Museum, the predecessor of Kelvingrove Art Gallery and Museum, had had proud possession of the engine from the paddle steamer *Industry*, built in 1814, and a massive James Watt beam engine. Though neither made it into the new building, Watt's own working model of his steam engine formed the nucleus of a room celebrating the great engines of Clyde-built ships and locomotives. These models were there because they were viewed as a paradigm for the fusion of art and industry, and could be admired from both a scientific and an aesthetic viewpoint. Watt's engine in particular is not just a triumph of form and function, but has enormous historical significance – his invention of the separate condenser changed the steam engine from an inefficient pump to the driving force of a global industrial revolution.

James Watt's improved steam engine was a personal triumph and the power behind modern industries throughout the world.

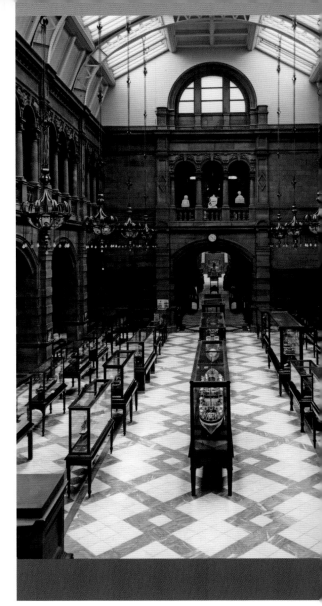

Model engines and model ships

Of course the working model engines were also a major visitor attraction and entertainment for visitors, and in the 1960s and early 70s, speaking as the daughter of a

ship's chief engineer, it was inevitable that our family visits usually gravitated to the engine display in the west of the building. The big treat for us as children, after gazing at these metal masterpieces that drove the world, was the trip to the shipping court (*pictured left*) with its treasure trove of scale model ships. This room was possibly one of the most dearly loved and best remembered in Kelvingrove. The models were there for nearly 80 years, until they moved across the city to the Transport Museum, then in Albert Drive. Models of the magnificent ships that had been built on the River Clyde had also been a major feature of the display in the demolished City Industrial Museum, and the collection had been added to considerably during the pre-war years when Clyde shipbuilding was still at its height. The shipbuilders who donated them didn't necessarily do so through altruism or civic pride; a splendid scale model of their product, displayed in a highly respected museum, was an early example of product placement advertising. Hence the quality of these models was second to none, and no child visitor would ever miss an opportunity to press their nose against the case of these miniature masterpieces, perfect in detail right down to the Lilliputian sailors standing to attention on deck.

Portrait of RL Scott, by Thomas C. Dugdale.

RL Scott and the arms and armour collection

The other collections that dominated the west part of the building included the magnificent Scott collection of European arms and armour. Robert Lyons Scott, who died in 1939, was the chairman of a shipbuilding and engineering company in Greenock. He was a man utterly fascinated by weaponry, an interest that started as a boy when he purchased a flintlock for a few pennies. The collection that grew from then on was once described as 'the most considerable collection in private hands'. In addition to collecting

Milanese field armour, about 1440.

these objects, he created an incredible reference library of over 3,000 books dealing with the military sciences, and was regarded as a major scholar in his field, particularly on the subject of fencing.

Treasures

Key objects in the armour section are the garniture (armour for man and horse) of Sir William Herbert, 1st Earl of Pembroke, made at the Royal Armouries in Greenwich around 1557, and the only complete example of its type to survive (*detail below*). The Milanese field armour, made about 1440, is probably the earliest near-complete plate armour in the

Basket-hilted sword, Scottish, early 18th century.

world. Scott purchased this in 1938 from the eccentric American newspaper magnate William Randolph Hearst. The armour, which is in almost perfect condition, remains a beautiful example of the armourer's art at the very highest levels of skill and artistry.

This astounding collection of weapons, covering the whole range of fighting implements from swords, daggers, and maces to crossbows, pistols and long guns, is most likely to stay in the imaginations of Kelvingrove visitors. A little known fact about these weapons is that Scott preferred to collect the equipment of real fighting men, everyday weapons rather than highly decorated artworks, display pieces or costume items. Many of the swords he collected may very well have drawn blood, and some of the pieces of armour certainly bear the scars of battle.

It's hard to know quite what to make of this collection. A man who was so obsessed by the detail and authenticity of arms and armour would of course wish his collection to be truly representative and feature objects that had performed their function rather than simply ornate showpieces. Scott was proud of being a big game hunter, a pursuit that in his time would have brought him wide admiration as being fearless and skilful. It was what rich gentlemen of the time did, although

we now view game hunting quite differently. From our twenty-first century perspective we might be tempted to see his interests as bloodthirsty, but what we can say for certain is that Scott was interested in real history, the experiences, deeds and fates of real people. And what we've been left is one of the most astounding, coherent and complete collections held by any museum in the world.

Kelvingrove also possesses some very fine examples of nineteenth-century Japanese armour, which have struck a chord with many visitors because of their striking combination of formality and flamboyance. These were not part of the Scott collection, but were purchased in 1958 for the heady sum of £20.

Japanese armour, 19th century.

'the most
considerable collection
in private hands'

Clockwise from top left, details of:
German cranequin, 16th century
Italian rapier, 16th Century
Scottish powder horn, 17th Century
German crossbow, 16th Century
South German grandguard, about 1560

this astounding collection of weapons, covering the whole range of fighting implements from swords, daggers, and maces to crossbows, pistols and long guns...

Detail from *Regole di Molti Cavagliereschi Essercitii*, by Federico Ghisliero, 1587.

Egyptology
Pa-ba-sa

Another major draw for visitors over the years has been the Egyptology section of Kelvingrove. The biggest exhibit in the collection is the splendid diorite stone sarcophagus of Pa-ba-sa (*pictured above*), a high official of King Psamtek 1 who reigned from 664 to 610 BC. Pa-ba-sa was in charge of the entire priesthood of Upper Egypt, and was a tremendously powerful figure. The sarcophagus is empty, which has proved a great disappointment to children through the years who wished to see a spooky bandaged mummy rearing up at them. It was donated in the early twentieth century by the estate of the dukes of Hamilton. Alexander, the highly eccentric 10th Duke of Hamilton, was a keen Egyptologist and was buried in another sarcophagus he had acquired at the same time, mummified in the Egyptian manner.

The huge carved sections of Pa-ba-sa's diorite resting place have always been a major attraction, and in 2005 when the sarcophagus was moved and opened to make it ready for the restoration, it gave rise to a mini excavation of its own. The two pieces of the sarcophagus had never quite fitted, and there was a gap between them. Since the last time it was opened (in the 1930s) visitors have been posting all kinds of material through the gap. Curators found a disgusting mix of filth, cigarette ends, gum and serviettes from functions, but, more interestingly, 70 years' worth of leaflets and ticket stubs from temporary exhibitions and events. Perhaps the most unusual find was a carefully folded 'girlie' magazine dating from the 1970s. Perhaps it's just as well the sarcophagus's occupant was absent, otherwise a superstitious person might worry what the master of priests, who believed he had power beyond the grave, might have called upon to revenge such a blatant act of disrespect!

The Egypt Exploration Fund

Egyptology was something of an obsession with the Victorians and almost every museum in Britain sought to have its own collection. Glasgow was no different, having collected Egyptian artefacts since 1877. From 1892 it was a subscriber to the Egypt Exploration Fund, a society that organized excavations in Egypt funded by contributions from individuals, universities and institutions. The objects discovered were distributed to the subscribers according to the percentage of their contribution, and through this process Kelvingrove acquired a great many objects of significant interest, including a fascinating collection of decorated ceramic Predynastic pots that date back to about 5500 BC.

Unfortunately the Council decided to halt the subscription in 1914 as a money-saving exercise. This meant that Kelvingrove lost out on finds from the Society's later work, including the astounding finds from their excavations at Tell-el-Amarna in the 1920s and 30s. These uncovered the mid fourteenth-century BC hidden city of the 'heretic' Pharaoh Akhenaten, who changed the religion of the people he ruled.

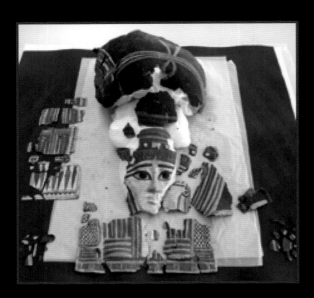

Cartonnage mummy mask (332–30BC)

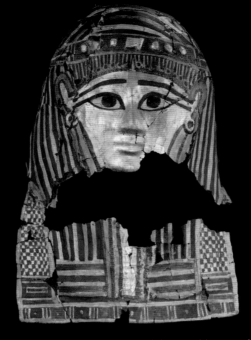

ANCIENT EGYPTIAN

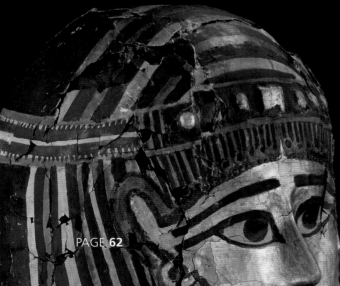

This Egyptian gilt cartonnage (plastered layers of fibre) mummy mask had been in a large number of fragments since the museum acquired it in 1902. The mask is made from linen soaked in gum, covered by a layer of plaster, and then decorated. To prevent any further damage to it, and so it could be put on display, it had to be conserved.

A layer of tissue soaked in temporary adhesive was applied to the front of the fragments to ensure that pieces were reconstructed in the correct order. Once that was built up, a more permanent adhesive was used on the back of the mask to hold the fragments together once the temporary adhesive was removed. A foam mount, covered with black fabric, supports the mask when it's on display. After over 100 years in a box, and with some skilful conservation work, visitors can at last see the face of this Ancient Egyptian.

The archaeology collection stretches across a wide range of countries and civilizations

Miss J May Buchanan

However, many other bequests and purchases ensured that the collection stayed relevant and continued to develop. A great friend to the collection was Miss J May Buchanan, a huge enthusiast and local honorary treasurer of the British School of Archaeology in Egypt. She organized an extremely well received exhibition of Egyptian antiquities in Kelvingrove in 1912, and when she died suddenly as a result of an accident that same year it was decided that donations to the collection would continue to be made in her memory. Some of the donors to the J May Buchanan Collection have included archaeologist and Egyptologist Professor Flinders Petrie, Miss NF Buchanan, and the Glasgow branch of the Egyptian Research Students' Association.

Miss Buchanan stands out as one of the very few women, in the sexist atmosphere of the early twentieth century, to be regarded as equal to her male counterparts in her passion for ancient civilizations.

Left: Cosmetic pot held by a kneeling girl.

Right: Detail of the inner coffin of Ankh-es-nefer.

Loans from the British Museum

Kelvingrove's Egyptian collection is now being joined by 84 superb objects on long-term loan from the British Museum as part of their Partnership UK scheme. These combine to tell the story of life, death and rebirth in Ancient Egypt. Guarded by two monumental black granite statues of Sekhmet, the lioness goddess, the displays have been organized into three stories targeted at specific audiences – families with young children, schoolchildren and teenagers. So the perfectly proportioned 12th-Dynasty stela of Sensobek and his father Intef shows how boys were expected to follow their father's profession, and a charming cosmetic pot held by a kneeling servant girl shows that looking good was as important to women (and men) in Ancient Egypt as it is today. And two Roman panel portraits of bejewelled Egyptian women from the British Museum perfectly complement Glasgow's own two young men.

At the centre of the gallery is the intricately decorated wooden coffin and mummy of the lady Ankh-es-nefer, still wrapped in her linen shroud and bandages. She's part of the story How to Survive Death the Ancient Egyptian Way (aimed at schoolchildren), which offers a slightly irreverent, but nevertheless authentically Egyptian, take on how Egyptians hoped to live forever in the afterlife. British Museum Director Neil MacGregor's offer to lend a 'roomful' of objects may become a new standard measure in museums!

The Lang Collection

The archaeology collection stretches across a wide range of countries and civilizations, and the Lang collection is one of the highlights. This consists of over 300 Cypriot objects, donated in 1903 by Sir Robert Hamilton Lang, a Scot who was manager of the Imperial Ottoman Bank's Agency in Cyprus from 1863 to 1872.

He was inspired by his location, and his interest in archaeology grew steadily until he was conducting excavations and purchasing items of interest. One of the unusual objects from his collection is a rare ceramic model throne dating from 900 BC, which features painted decorations imitating a woven or lattice work seat.

James Stevenson

James Stevenson was another Scottish collector, and a wealthy partner in a chemical manufacturers. In the 1870s, to provide a source of sulphur for his business, he bought the Aeolian island of Vulcano, near Sicily, for the sum of £8,000. He built a factory next to crater of the island's live volcano, and when it erupted on three separate occasions from 1888 to 1890, he was blamed for this. The islanders thought his Presbyterian beliefs had driven away the island's Roman Catholic priest, bringing bad luck, and his family imagined his factory had caused seismic disruption. Stevenson left the island to go cruising on his steam yacht, and never returned.

Prior to this, in 1879 he had bought the contents of 20 Ancient Greek tombs discovered on the neighbouring island of Lipari. These finds were shipped to Glasgow in 1885, put in the safekeeping of Kelvingrove and donated to the museum on his death in 1903. They include treasures such as delicately adorned pottery by an artist known to archaeologists as 'The Lipari Painter', and a very rare ceramic calyx-krater (*pictured above*), a vessel used for mixing wine with water.

St Kildan Finlay Gillies launching a mailboat. These little wooden boats held a letter and postage sealed in a cocoa tin.

St Kilda and beyond

Antiquities from Scotland are a strong part of the collection, and range from the prehistoric up to 1930s' household objects from the evacuated island of St Kilda.

St Kilda

When steamships began sailing to this isolated Scottish community in the 1870s, the items visitors brought back were of enormous value in illustrating the ingenuity of the local people in overcoming their hardships. The islands are treeless, and any wooden items had to be made from driftwood, or timber that had been brought in by the rare visitor. So wood, a material most mainlanders would consider commonplace, was highly valued and largely used only for important items. The collection includes spinning wheels and beautifully crafted bird snares – puffins, fulmars and gannets had been the mainstay of island survival and provided food, oil and down.

Ludovic MacLellan Mann

The largest collection of ancient Scottish objects was donated to the museum by amateur archaeologist Ludovic MacLellan Mann. His main occupation was as an accountant and insurance broker, but his passion for ancient history was the driving force in his life, and the collection he bequeathed to Kelvingrove is of enormous value in terms of its variety and scope.

Some puzzling stone balls are a curious part of this collection (*example above*), and they have fascinated visitors ever since they were first put on display in the museum. They were found in large numbers in the northeast of Scotland, and date to around 2500 BC. Their sophisticatedly carved surfaces reveal a number of intriguing designs, which look surprisingly modern in the elegant simplicity of their execution. However, historians can find no obvious use for these objects, either utilitarian or ceremonial, and so their use and origin remain to this day a complete mystery.

When is a jacket not a jacket?

When it comes to identifying objects, even the experts sometimes get it wrong. A jacket dating from between AD 500 and 700 had been in Kelvingrove since the 1960s, when a staff member had excavated it from a crannog in Loch Glashan in Argyllshire. This was an exciting find, and the jacket was mounted to keep it flat, and put on display. It was only after research conducted with the aid of funds from Historic Scotland that suspicions were raised that this was not quite what it seemed. A conservator removed it from its mount and it was examined in greater detail – it was found to be a satchel, the only one like it in Scotland (*artist's impression below*). This unique object has now been re-catalogued, and further research may reveal more about its origins now that curators understand its real purpose.

The Gavel Moss Hoard

The Gavel Moss hoard is a Bronze Age dagger and two axeheads found in 1790 by a farmer ploughing his field at Gavel Moss Farm in Renfrewshire. They were kept in the family until 1959, when they were sold to the museum. It's thought that these weapons may have belonged to one individual, and their excellent condition means that the decoration can be clearly recognized and dated to around 1600 BC.

The Human History Collections

If there have been major changes in any part of the collection, in terms of how it has been interpreted over the decades, then it must surely be in human history. The Victorians regarded the world and its inhabitants in a very different light from the way we do today. There is no longer any legitimate sense of superiority in the way we in the West view our fellow man, and so the objects that must have once spoken to an audience about primitive and backward existences tell us quite different things now that we can reinterpret the lives of those who made and used them. The staff involved with Kelvingrove have been quite extraordinary in being at the forefront of this

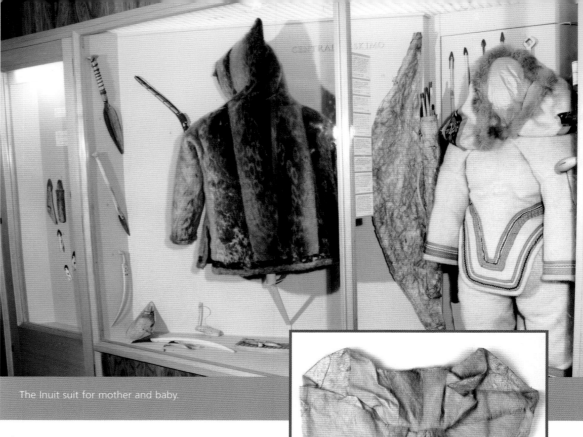

The Inuit suit for mother and baby.

refreshed attitude. Glasgow has proved itself capable of keeping Kelvingrove at the forefront of curatorial excellence, while at the same time working towards an inclusion policy that is the equal of anywhere in the world.

Human history is represented by 70,000 items from all over the world, and a particularly memorable display for past visitors was the Inuit suit for a mother and baby. This was acquired in 1915, and the suit was believed to be from about that time too. Perhaps because it so ably demonstrated the aesthetics of necessity, it made a very popular exhibit. However, there was an item that came with the suit that was not displayed – a rather large pair of lady's bloomers made of caribou fur (*pictured above*). This is a pity, since such a garment would have definitely resonated with many Glaswegian ladies on a chill February morning!

Te Papa

Most recently, the Working Group voted unanimously to repatriate three 19th-century toi moko – preserved Maori heads – and a thighbone to the Te Papa Tongarewa Museum, New Zealand. These were handed over in a ceremony at the end of 2005.

As time goes on, museums that encompass world cultures will have to deal with increasing numbers of requests of this nature. The decision will always have to be made between the value of the object to the individuals attempting to reclaim it, and the value it has to the greater public, internationally as well as locally. So it's not just the contents of Kelvingrove that do Glasgow proud, but also the way they have been housed, curated, conserved, constantly researched and reinterpreted, and most importantly, genuinely cherished by those charged with their care.

James Te Puni of Te Papa and Councillor John Lynch with the crated toi moko.

Repatriation
The Ghost Dance Shirt

The Lakota Sioux Ghost Dance Shirt was a Native American shirt that may have been worn by a warrior who fell at the massacre of Wounded Knee in South Dakota. It was originally acquired from George C Crager, a Lakota interpreter with Buffalo Bill Cody's Wild West Show which came to Glasgow in the 1890s. Crager wanted to dispose of various artefacts he had before returning to America.

A century later, in 1994, the shirt hit the headlines when it was made the subject of a repatriation application by the Wounded Knee Survivors' Association of the Pine Ridge Lakota. The Repatriation of Artefacts Working Group,

Marcella Le Beau (*left*) presents the new shirt to (then) Councillor Liz Cameron.

chaired by Councillor John Lynch, was set up by Glasgow City Council to consider such applications. In a changing world, with better communications and renewed cultural identities, such applications are inevitable. In 1998 the application was successful, and in 1999, a delegation led by then Councillor Liz Cameron took the Ghost Dance Shirt to South Dakota. It was handed over to the Wounded Knee Survivors' Association at the site of the massacre with due ceremony, and is now on display at the South Dakota Historical Society. A new shirt was made and presented to Glasgow Museums by Marcella Le Beau of the Association.

THE
KELVINGROVE
NEW CENTURY
PROJECT

From Victorian Building to 21st-Century Museum

When Kelvingrove celebrated its centenary in 2001, many Glaswegians, unaware that talks were afoot to restore the building and displays, must have had heavy hearts. Here was a city celebrating its most cherished public building while that very amenity was crumbling before their eyes.

Its degeneration was a mark not just of how the passage of time had chipped away at the physical fabric, but also of how radically society had altered in the course of only a few generations. Despite the astonishing amount of activity in international trade and industry, and the migration to the city of thousands of Irish, Eastern European and Russian Jews, and Italians, late nineteenth-century Glasgow was not exactly cosmopolitan in its mix of inhabitants. The Art Gallery and Museum's curators therefore assumed, probably with good cause, that they were addressing a largely Caucasian, indigenous audience who, regardless of their political or religious background, regarded the rest of the world from a consensual viewpoint of British Imperial superiority.

IF YOU ARE A STRANGER THE ATTENDANT WILL DIRECT YOU WHERE TO STAND, WHEN TO STAND AND WHAT TO STAND. THE GALLERIES CLOSE AT 9 P.M. PROMPT

1933

Access issues

The idea that people with physical impairments or learning difficulties could, and should, have a full role in society, including the right of access to places like Kelvingrove, would have been regarded with amused incredulity in 1892. The adjustments that had been made over the years, in order to address the changes in attitude and the needs of a more diverse mix of citizens, were severely limited by both the building's layout and the traditional orthodoxy of museum design. By the time society had decided that certain rights, like access, were important, there was little that could be done to implement them in Kelvingrove with grace. Lifts for wheelchair users, for instance, had to be crammed into awkward corners of the building, making these visitors feel second class and unwelcome; parts of the upper floor, where steps led onto a landing, were completely inaccessible.

Raised expectations

The displays themselves, though indisputably well loved and appreciated by millions over the years, had nevertheless failed to keep up with the modern Glaswegian's expectations, raised substantially by travel, better education and experiences of international visitor attractions. Given that Kelvingrove's collections are rightly regarded as world class,

1932

> By the time society had decided that certain rights, like access, were important, there was little that could be done to implement them in Kelvingrove with grace.

REDECORATION SCHEME AT GLASGOW ART GALL

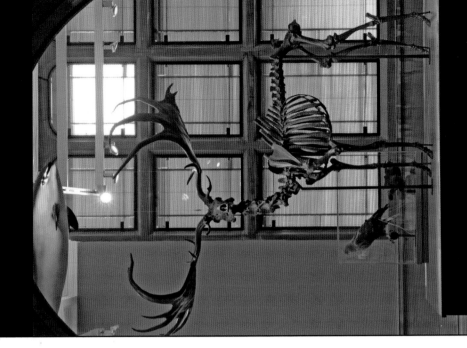

The complete skeleton of a giant Irish deer - one of Kelvingrove's natural history treasures.

the problem was not with the objects themselves, but more with lack of context. Despite the best efforts of curators and designers over the decades to bring the collections into the light of modernity, there had always been a difficult line to tread between the duty to provide opportunities for peaceful contemplation of objects and paintings, organized in the traditional manner of chronology or provenance, and the more crowd-pleasing dynamics of interactivity and multimedia interpretation.

Godzilla or Jurassic Park?

It was particularly disappointing for a generation of children who took blockbuster movies like *Jurassic Park* for granted to rush to the dinosaur section and be confronted with a peeling model of a *Tyrannosaurus rex* that resembled a toy store Godzilla, presiding unthreateningly over Victorian cases crammed with fossils and curling yellow labels held down by pins. Nor were important displays, such as the magnificent Scott collection of arms and armour, crammed together in cases with little room for the fuller explanations they deserved, reaching anything like their full potential to make visitors contemplate the implications of their invention and use.

First floor flops

In addition to the dichotomy of whether to entertain or merely present, the problem of how visitors moved about the building, and where the flow took them, was thrown sharply into relief following a detailed study by the Architecture Department of Cardiff University. Researchers followed visitors around for the first 20 minutes of their visit to Kelvingrove, counted the number of people in every gallery, and counted the number who passed through each doorway every hour. The survey found that fewer than 30% of visitors ever made it up to the first floor. Here was shocking news – that 70% of all visitors were missing out on the magnificent fine art collection that had been the very starting point for the building's existence.

This information formed the basis of a radical decision – to display art on the ground floor. Showing art there posed significant design problems – the original design of the building had top-lit galleries for paintings on the first floor, and side-lit galleries for history and natural history on the ground floor. But these problems were worth solving to make sure that visitors were introduced to fine art, and tempted upstairs to the rest of the collection.

Despite Simpson and Allen's simple symmetrical plan, the natural flow that originally took visitors round the building, guiding them effortlessly upstairs, had been interrupted over the years by the positioning of large display cases that blocked views and access, and partitioned administration or storage areas. And there was a further problem. While existing exhibits had lacklustre environments, or were not interpreted outside the narrow context of their group, a whole host of other exhibits had never seen the light of day and were languishing in storage.

All these considerations occupied the minds of Glasgow City Council and Glasgow Museums staff as they pondered how to take Kelvingrove forward into the twenty-first century.

The way forward

Some of these obstacles to improvement could have been dealt with in piecemeal fashion – the decaying fabric of the building could have been patched up for another few decades, and the displays refreshed but not substantially altered. After all, these are difficult economic times for most modern British cities, with legitimate cries for cash coming from almost every section of society.

Perhaps the public would have been content with such a frugal and minimal makeover, and Kelvingrove could have continued drawing the crowds with nothing more than a bit of stone repair and a lick of paint. However, in a spirit of boldness and foresight that is only too rare in our public servants, the exciting decision was taken to completely overhaul and transform the building, and to totally rethink the design and display of the collection.

Funding for this massive £27.9 million project was raised from the Heritage Lottery Fund, which provided nearly £13 million (the biggest grant to date in Scotland), Glasgow City Council which set aside £6.5million, the Kelvingrove Refurbishment Appeal Trust which, by the close of the appeal raised its original £5million target and an additional £7.5million for enhancements, the European Regional Development Fund, Historic Scotland, who donated a further £500,000, and Scottish Natural Heritage.

The final decision was taken in February 2002, and the Kelvingrove New Century Project (KGNCP) was underway. Already in hand as part of the plan was the building of Glasgow Museums Resource Centre (GMRC) at Nitshill on the south side of Glasgow. GMRC was designed as a broad-based educational

Glasgow Museums Resource Centre, Nitshill.

facility with substantial new, climate-controlled spaces for secure long-term storage and conservation work. Clearly this was essential, given that the entire collection at Kelvingrove, worth an estimated £565 million, would have to be removed and stored while the restoration work was being carried out.

Art Treasures of Kelvingrove

Another important aspect was the plan to hold a temporary exhibition, Art Treasures of Kelvingrove, at the McLellan Galleries. This opened in April 2003 and served the dual roles of continuing to provide public access to some of the cherished items in the City's collection, and sustaining interest in the project. With these elements in place, the architects, Building Design Partnership, were appointed, the work began, and the dream of a new Kelvingrove for a new generation became a reality.

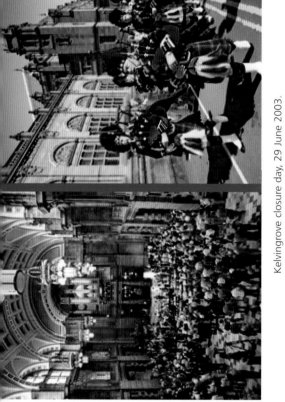

The *Art Treasures of Kelvingrove* exhibition.

Kelvingrove closure day, 29 June 2003.

An important exhibit leaves Kelvingrove in 2003 – with an audience!

It took 50 staff three years to pack and decant all the objects

The Decant

The process of decanting the objects from their homes in Kelvingrove into storage was a lengthy one, and started in 2001 when the team correctly anticipated a green light for funding and started packing. With 200,000 objects stored in Kelvingrove, this was no small task, and the statistics of the move are sobering. It took 50 staff three years to pack and decant all the objects, using 7,000 metres of bubble wrap, filling 2,000 boxes and 3,000 trays of natural history and geological specimens, and covering 500 miles in van trips between Kelvingrove and Glasgow Museums Resource Centre. Some of the objects were too big or too heavy to move, and had to remain in Kelvingrove. These were carefully boxed in to protect them during the building works, and amongst them was the famous stuffed elephant, Sir Roger, who has never left

the museum since he arrived in 1902 and now, it seems, never will. Also staying put were the organ in the centre hall, various sculptures including the John Flaxman figure of William Pitt, and the massive diorite sarcophagus of Pa-ba-sa.

When the picture galleries were finally de-installed in February 2003, their precious contents were taken to the McLellan Galleries or into storage at GMRC with an impressive and traffic-stopping police escort travelling at walking pace. On 29 June 2003, over 12,000 people turned out to say a temporary goodbye to Kelvingrove, and Councillor John Lynch, Convener of Cultural & Leisure Services, locked the museum's doors. The building was at last ready to undergo its transformation.

Work begins
Up on the roof

Builders started on site in August 2003, and first on the agenda, with obvious logic, was the roof. Scaffolding was erected so that the roof lights above the galleries could be replaced with double-glazed UV protective glass, and new asphalt and lead work could be fitted. Several of the high ornate pavilions that are so much the trademark feature of the building's famous skyline were found to be leaning slightly and dangerously unstable. Instead of straightening them out, the towers were made safe at the angles they had settled into by wiring and bracing them from the inside.

The last task at roof level was a trying one. A peculiar feature of Simpson and Allen's design is that all the drainpipes are internal. This has the great aesthetic advantage of providing a facade entirely free of unsightly pipes, but when the time comes to maintain or replace these, the difficulties are obvious. With inaccessibility the main problem, twenty-first-century technology came to the rescue. Small closed-circuit television cameras were lowered into the void, showing pictures of the pipes' interiors for the first time in 100 years. Using the cameras to guide the work, a liner was then inserted into the entire length of each pipe.

One wonders if any of the team involved were horror film fans, and lowered the cameras with trepidation – what might they see blinking up at them on the screen? Something scaly perhaps, and cross at being disturbed after having been hidden from view for a century in darkness? Unsurprisingly, there were no gremlins, and all they saw was ten decades' worth of sludge, which was quickly dealt with.

Inside jobs

Once the roof was completed, work began inside. After important historic fittings like doors or panelling had been removed and stored, it was time to lift and renovate the gallery floors. In 1901, in an age when the world was still seen as an inexhaustible cornucopia of resources instead of the fragile, threatened planet we've made it today, the provenance of materials was of little importance. Hence there was no problem in felling ancient hardwoods for the joinery, and flooring the entire gallery space with a beautiful red-hued Burmese teak. As part of the restoration, all the wooden floors were due to be lifted so that power for the modernized

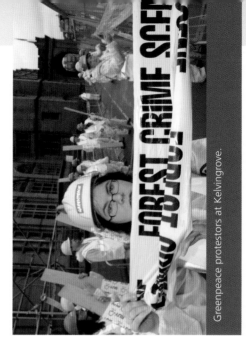

Greenpeace protestors at Kelvingrove.

displays that were to come could be inserted. However, the ground floor galleries, having seen considerably more wear and tear than the first floor, needed to be completely replaced. Upstairs could get by with being patched and repaired using salvaged boards from the stripped galleries below.

Choose your wood carefully

The difficulty rose immediately over what kind of wood to use as a replacement for the original teak, a material no longer considered appropriate by a council and museum keen to be ecologically sound. After consultation with Historic Scotland, the organization charged with vetting planning decisions concerning this A-listed building, merbau, an Indonesian red hardwood, was chosen as closest in tone to the original. This material came with a formal accreditation from the Indonesian government, assuring the buyer that the wood came from sustainable forests. So the purchase was made, and the floors began to be laid.

Unexpected occupation

What no one expected, having gone through this rigorous process to ensure that an ethical path had been trodden, was what occurred on 6 September 2004.

At 8.00am, about 100 activists from

Greenpeace, a campaigning organization that seeks to expose global environmental problems, entered Kelvingrove and removed packs of the timber, replacing it with wood certified by the Forest Stewardship Council (FSC). At the same time, four more Greenpeace members scaled the front of the museum and unfurled a banner reading 'National Lottery: Funding Rainforest Destruction'. It took about four hours, with senior museum officials holding talks with the activists in the presence of the police, to persuade them to leave. They did so by lunchtime, having cost the project valuable downtime.

It transpired that Greenpeace had discovered the Indonesian government's accreditation to be incomplete, and that the wood in fact came from rainforests where tree felling was threatening the extinction of the native orang-utan The Council, hardly full of evil, exploitative anti-environmentalists, but

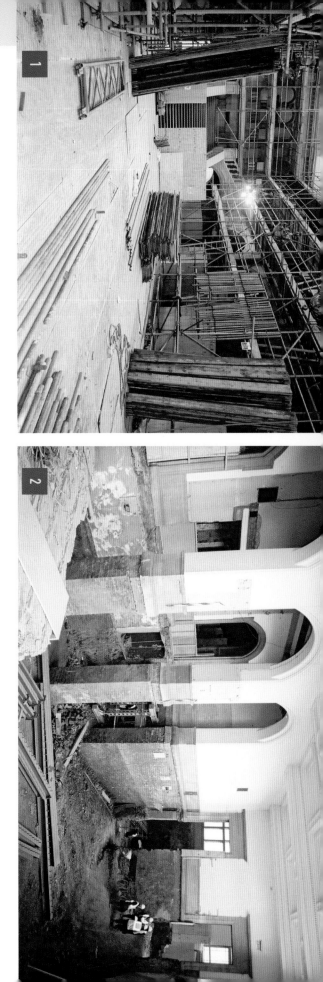

1 The west court after removal of the arms and armour displays. It has become the new 'Life' court, home to the Spitfire.

2 Rubble and infill below the old café were excavated to create the new lecture room.

3 The old basement was refloored and transformed into the Lower Ground floor, home to the temporary exhibition gallery.

4 Two staircases were built to link the new entrance foyer to the centre hall. Red is the colour associated with the east court and blue with the west.

on the contrary, highly motivated, ecologically aware people with precisely the same principles as Greenpeace, would have been grateful for that information, but perhaps provided in a more traditional fashion. Work on the flooring was immediately stopped.

The positive outcome was that museum staff worked with Greenpeace to ensure that new timber met the FSC standards that had been stipulated in both Council policy and the original flooring specification. With Historic Scotland's permission, a handsome, politically unassailable, North European beech was selected and stained to match the original teak. The floors were at last back to their original, gleaming, polished splendour, and no primates had suffered in the process.

Meanwhile, down in the basement

Also underway was perhaps the greatest and most ambitious part of the building project. This was to turn the existing basement, previously used for storage and administration, into useable visitor areas, and to excavate an entirely new area to create 1,789 square metres of space. This engineering feat took an entire year of toil, but the results are a resounding success. The reclaimed basement houses the education suite, the new temporary exhibition space, the shop and the café, while the newly excavated area houses the lecture theatre, the kitchens and the Campbell Hunter Education Wing, funded by millionaire entrepreneur Tom Hunter. The infill dug from the bowels of the building was put to good use as hard fill for the new car park areas, and so never left the

...down in this newly created part of Kelvingrove yet more innovation was taking place.

site. It is similar small time- and money-saving pieces of ingenuity throughout the process that contributed to the project being one of the very few major public initiatives to come in bang on budget and on time. For that reason, the importance of smart thinking cannot be underestimated.

One unpleasant surprise was the discovery that there was no floor in the basement, only a skin of cement on the earth. And as this was unexpected, it was also unbudgeted for. But another clever suggestion saved the need for prohibitively expensive floor tiling throughout the new basement. A company had experimented with an unusual process on their own premises, and discovered that ordinary poured concrete with aggregate sprinkled through it could be levelled with a grinder until the highly polished surface resembled high quality granite. A trial gave the promised effect, and the entire basement

floor was duly floored in magnificent style for a fraction of the cost of an equivalent effect in genuine polished stone. ('What sort of marble is that?' asked one visitor.)

And down in this newly created part of Kelvingrove yet more innovation was taking place. Catering facilities in the building had always seemed to be low priority. Those of us old enough to remember will recall the tearoom, hidden up on the north landing of the first floor, and impossible to find except by regular visitors with good memories. The café at the east end of the ground floor was a better attempt to be accessible, jolly and wholesome, even sporting child-pleasing pieces of modern sculpture by George Wyllie and featuring flowers and musical instruments. The twenty-first-century customer, however, expects top class eating and drinking as an essential part of a visitor attraction, and the KGNCP kept this very much in mind. Without

encroaching on the new spaces created to accommodate displays and education, a radical plan was adopted. Two stunning glass pavilions were designed to be pinned onto the exterior north wall, keeping the sandstone exterior as the new interior wall. The eastern pavilion was arranged so that diners would have a glorious view into the park, and a rare

opportunity to eat al fresco, should the constant drizzle of a standard Scottish summer let up for long enough to finish a cup of coffee. On the western side of the new north entrance, the second pavilion was formed to make an attractive, light-filled addition to the education space.

Historic Scotland initially had reservations about this scheme, given that it was going to alter the exterior of the building. However, on recalling that the original Simpson and Allen design had planned for this same area to be the sculpture studio of the proposed School of Art before the scheme was abandoned, it was decided that this could be permitted. No doubt Historic Scotland's decision was also based on the fact that the design was sufficiently elegant and unobtrusive to ensure it would not detract from the aesthetics of the building, nor indeed interfere with the magnificent 100-year-old

London plane trees that flourish just yards away from the proposed new build. There's little doubt that hungry visitors and school students alike are going to have a long and happy relationship with this newly created amenity. A few autumn leaves falling onto the glass roofs is a small price to pay for sipping a glass of wine in the dappled shade.

Cleaning the stonework

Back inside the building, the task remained to undo the damage that decades of dirty Glasgow air had visited on the smooth sandstone, a process that had gradually mutated its beautiful blond biscuit hue into a grimy depressing grey. Whilst the exterior stone had received one big clean up in the 1980s by a method involving chemical solvents and high pressure water hosing, the stone inside had never been touched. This was due to a nervousness born of experience.

Abrasive or steam cleaning, acceptable at the time the exterior was done, has since been proved to have a detrimental effect on the longevity and appearance of stone. Historic Scotland were rightly concerned about how the interior masonry might suffer under a similar procedure. To this end, a whole host of approaches were explored. Trials were done with modern methods of steam and abrasion,

in addition to chemical and laser cleaning. Not only were the results poor, but they were so laborious as to be non cost-effective. Finally a completely new method, pioneered to brilliant effect on London's St Paul's Cathedral, was offered as an option and showed immediate promise.

The method, called Arte Mundit, involves a chemical-infused latex being sprayed onto the stone's surface, left for a crucial time period, and then carefully peeled off. The latex absorbs the dirt, and when peeled away the stone beneath is left clean and totally unharmed. Professor Norman Tennent, former Head of Scientific Conservation at Glasgow Museums, was brought in to assist a team of consultants with trials.

Part of the challenge was that the staining of the interior Giffnock stone was varied and due to different causes. Professor Tennent developed special potions for the

The results were instantaneous and spectacular

particularly stubborn stains, and after the experiments proved successful, work began. This was the very first time this process had been used in Scotland, and those applying it were not to be disappointed. The results were instantaneous and spectacular. A small patch of stone has been left on the first floor eastern balcony so that visitors can see for themselves the tremendous transformation the stone had undergone.

Elsewhere in the building, all the accretions added to the building over 100 years were removed. For the first time in decades, visitors are able to do a complete circuit of both floors without being impeded by galleries converted in to classrooms or meeting rooms. Vistas that had been blocked for generations have been opened up and the original splendour of the architecture revealed.

While the interior was transformed, and the serious structural and cleaning work completed, curators and designers had been working on the displays. However, one of the new exhibits was to prove so troublesome in the quest to display it to its best advantage that the engineers were not quite ready to hang up their hard hats.

Spitfire LA198

The magnificent 602 (City of Glasgow) Squadron Spitfire (*below*) was to be the key attraction in the west court, and the plan was to hang it from the ceiling. Restored as a joint project between Glasgow Museums and the National Museums of Scotland, and funded by the Scottish Executive, the plane was to be viewed from above and below. Measurements were taken, and with the aircraft angled as if swooping low through the building, there would be just centimetres between the wing tips and the first floor balconies. Judging such tiny tolerances would a precision job, but the excitement for visitors to see the plane at such close quarters would most certainly be worth it.

Almost immediately a major problem arose. In order to hang such a major weight from the ceiling, it would be necessary to have

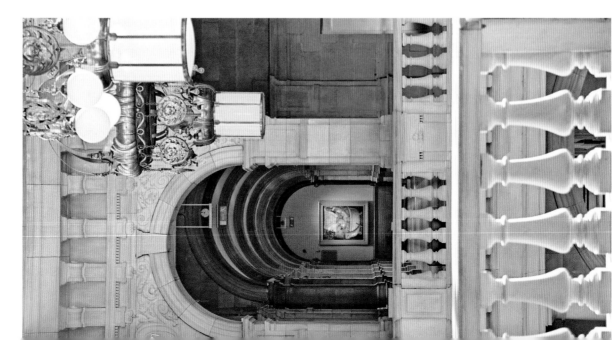

steel cables running from the plane to fixings on the building at as wide an angle as possible. This would lessen the strain on the ceiling and walls, and prevent the possible disaster of pulling down a bit of Kelvingrove. However, while these cables would put less strain on the building, they would also pull the aircraft apart. In other words, the correct hang to protect the plane would harm the building, and vice versa.

The solution was found by running a massive steel beam across the existing iron ribs vaulting the ceiling, and ingeniously making the beam in two parts, meeting in the middle by compression, much like the keystone in an arched bridge. This allowed the plane to be hung correctly with the reassurance that no one was going to be in the unfortunate position of having an 11,290-pound fighter plane land on them unexpectedly. The fact that the cushioning bulks of Sir Roger the elephant and a large giraffe are amongst the exhibits directly beneath is no reflection of a lack of confidence the engineers may have had in their plans!

First the Spitfire had to be moved from its temporary home at the Museum of Transport across the road. Then it took five independent teams of experts working fulltime to make this dramatic display happen. One team put the aeroplane back together while others manufactured the special fittings for the hang. Another team made the beam and fixed it, and another designed the hanging system, until finally, a separate group of lifting experts were responsible for raising the aircraft into the final position. Undoubtedly. The visitors who will gaze up in wonder at the underbelly of the aircraft, or down into its cockpit for decades to come will probably know little of the effort it took to get it there. It will be a jaded imagination indeed that is not ignited by the magnificent aircraft's presence.

The redisplays

The stage was successfully set to receive the reassessed, reconceived and revamped collections, and this in some ways may challenge the public's taste more than the major building alterations.

We, the public, are fickle creatures. We complain when change is slow in coming, and often complain louder when it does happen. Clearly, with so much innovation having been applied to the building, the changes to the Kelvingrove displays had to be radical, but nevertheless retain the key elements that made it the treasured public amenity it has always been. How then, were the display themes going to continue to interest and delight while at the same time be more relevant to the public's own passions and interests? How could the real significance and human story of an object be revealed without undermining its previous status?

After extensive research and consultation with community groups, it was decided that the new displays needed to be both flexible and responsive, and a world away from the rigid Victorian assumption that everyone came to an object with a broadly similar cultural and educational background. The choice of displays would therefore be based on two criteria: visitor and audience interest, and the significance and strengths of the collections.

The gallery themes

Keeping these criteria to the forefront, 22 themes were chosen, from the obvious such as French Art or Ancient Egypt, to areas never before explored thematically, such as Cultural Survival, Glasgow and the World and Every Picture Tells a Story. The themes were kept short and simple, not because there was any attempt to 'dumb down' information, or assume that a modern audience weaned on

The stage was successfully set to receive the reassessed, reconceived and revamped collections, and this in some ways may challenge the public's taste more than the major building alterations.

MTV had the attention span of a goldfish, but because the themes would be vital orientation points to help visitors navigate the building, physically and intellectually. In order to make this even more accessible, the uncomplicated solution was to divide everything into two main categories – Life and Expression. These would be located on opposite sides of the building, Expression in the east and Life in the west. With the added assistance of marking orientation points with large, hard-to-miss objects like the Spitfire or giant Irish deer, there would be no more hopelessly lost visitors trailing around trying to make sense of where collections could be found.

The philosophy

Having opened up the natural flow of the building, both materially and thematically, it was important that information should now flow freely too. In this world of convergence, compartmentalizing knowledge is recognized as a tired concept. This was an exciting opportunity to unite, for the first time, objects that previously seemed to have little or nothing in common. The themes were to reflect areas of public interest, but also to suggest possible context rather than implying an all-encompassing narrative or historical

perspective. For instance, controversial as some might think it, the Glasgow Stories display was not planned to be the usual gallery of historic bearded dignitaries, with labels talking up their civic contributions and achievements. Here instead was a proposal that objects could tell a real story about the city, even if some of that reality was uncomfortable. So objects that explain the genius of James Watt would sit alongside objects that speak of sectarianism, violence towards women, mental health care in the city, and more whimsically, the eccentric Glaswegian love of Country and Western music.

Similarly, the unique and internationally important RL Scott collection of arms and armour, previously isolated in its own gallery, would now form part of the gallery dealing with conflict and its consequences. Here, these weapons could be viewed in the context of their original, less than savoury, purpose, instead of seen solely as art objects with no more impact than harmless replicas hanging above a Highland hotel fireplace, or only as military history. Metal designed to cut flesh, and how it does it, could be connected to objects that explain why anyone would require it to do so. The Holocaust: Remembering for the Future and Souvenirs of War stories would

explore, with the help of Scott's grisly arsenal, precisely how inventive we are at finding new ways to kill people. Hopefully the visitor would leave wondering why, instead of merely marvelling at the beautiful filigree work on sword pommels.

If this sounds prescriptive and bullish, using objects that should be viewed neutrally as tools for political or philosophical comment, then nothing could be further from the truth. The new thematic connections and ignition points for contemplative comparison are not intended to lecture and force opinion. On the contrary, they are intended to stimulate the visitor into reappraising a collection they may already be familiar with, and come to their own conclusions.

Themes in art

The same was planned for the art collection. Whilst themes for art displays are often by chronology or country – and this indeed had been well established as the gallery's previous approach – subject and style are equally important for interpretation. The extension of this principle to include an art object can make even more sense of what's being looked at. For instance, instead of merely presenting the collection of Italian Renaissance painting

in a traditional 'flat art' gallery, it was decided that bringing in art objects and related material from the period could give a better overview of how brutal times and crude materials were overcome to create some of the world's greatest art.

In the Every Picture Tells a Story gallery, famous narrative paintings such as the exquisite Burne-Jones' *Danae* and Pettie's mischievous *Two Strings to Her Bow*, share space with an Islamic shield, a Burmese ivory elephant tusk and a Maori ship's stern. Here, the visitor is invited to understand more fully, by comparison, how art and craft alike have been used to weave a tale. Just as the Life category of the new display has its destination galleries, so too would Art.

Keeping in mind the survey that revealed visitors were reluctant to visit the art on the first floor, for the first time in Kelvingrove's history some of the permanent art collection has come downstairs to meet the visitor. Down have come the Scottish Colourists and Glasgow Boys, including the wonderful Henry and Hornel *The Druids – Bringing in the Mistletoe*. The east wing, formerly the café, is now the must-see Mackintosh and the Glasgow Style gallery, complete with reconstructed tearooms and a light-sensitive area to display the delicate

fabrics and watercolours that cannot withstand daylight. Hopefully, having been excited by the art, many ground floor-only visitors will at last be tempted upstairs to see what else is on offer. There they will find the star attractions such as Rembrandt's *A Man in Armour*, and of course Salvador Dali's *Christ of St John of the Cross* finally restored to what many consider to be its rightful place at the end of the west corridor. They will find much else too. As well as French and Dutch art, a new display explores Scottish identity in art, examining how our image is rooted in history and myth, once again with the combined use of paintings, objects and curios.

Multimedia displays

This broader view was to be the new ethos of modern Kelvingrove, but there was so much more planned than simply the reinterpretation of the collection. To the museum and art world, 'interactivity' has been either a buzzword or a dirty word, depending on your point of view. Ever since institutions such as the Jorvik Viking Centre in York came up with the idea of turning history into a theme park ride, the museum world has sat up and taken note.

Perhaps the public were tired of simply staring at things through glass. They wanted more. The counter-argument was that

peaceful absorption of information should be sacrosanct, and that popularizing exhibits risked cheapening them and suggested that the visitor had become too stupid to understand the wonder of a fossil unless it sang and danced. However, the great museums of the world have since proved that a combination of interactivity, entertainment, education and peaceful contemplation can and does work, and this is the model that Kelvingrove has sought to emulate.

Kelvingrove had already embraced new technology some years ago, with Kidspace, the first interactive gallery for under-8s in the UK. Initiated by Jem Fraser, then Museums Education Officer, this gallery won a number of awards. And although some technical difficulties were experienced in those early days, technology has marched on and once again, Kelvingrove is at the forefront of using multimedia to educate and inform.

Apart from the extensive new education facilities in the basement, there is much to

A screenshot from the interactive based on Pettie's *Two Strings to Her Bow*.

invite the visitor, particularly young visitors, to have more of a hands-on experience. For example, visitors can understand how historical clothing affected posture and walking by trying on replica costumes and watching themselves in a mirror. Youngsters can challenge the abilities of animal record breakers by comparing their own limb sizes or speed and agility. So many more objects have been made available to touch and explore, the honey bees and their hive have come back, masks can be tried on, replica objects can be painted and decorated, and almost every display has some aspect that, if not interactive itself, leads directly to something that is. Even the simple idea of providing flip-over labels of information beside each painting in the nineteenth-century French art gallery for those who wish to know more turns the passive act of gazing at a picture into an active quest for more understanding.

In addition, the site of the old tearoom on the north landing has become a study centre. Here, visitors can get in amongst the nitty-gritty of historical lives by looking things up for themselves, and most importantly being able to question and be advised by curators on duty who will answer questions, receive objects for identification, and generally be the human face of this massive bank of knowledge.

The display cases

All this innovation and exciting change had to of course have a homogenous 'look'. Some of the cases at Kelvingrove actually dated back to the City Industrial Museum in the Kelvingrove Mansion, and were themselves historical objects. When the old displays began to be dismantled, some of these cases just fell apart, but some survived and were carefully taken into storage. One has remained, proudly restored and reinstated in the Scottish Identity in Art display.

The new case design had a lot of work to do. Given the nature of the new displays it had to be interchangeable and modular, but also offer the opportunity of separate identities for each of the new and distinct areas of the

museum and galleries. As stories may change on a regular basis, this was no small task. The eventual design is an elegant system of glass, metal, and plywood units that can be altered in many ways, and given coloured and textured backgrounds or sides to meet the objects' display requirements. Being mostly glass, the case design also ensures more expansive views through them where required, particularly on the ground floor where new vistas have been opened up.

Backing up this modern, but not over obtrusive design is an extensive and dramatic use of graphics, including large photographic montages, and the ingenious three-dimensional graphic landscapes created for the Scotland's First Peoples gallery.

Where's my favourite....?

Of course, even if visitors are dazzled by all this innovation, an inevitable question is bound to arise – 'Where's my favourite exhibit gone?'. Even though hundreds of square metres of extra space had been created, displaying 8,000 objects instead of the 4,000 previously on display, some things had to be packed away.

Amongst the items now in storage are the Thomas Lipton silver, and the massive E Roscoe Mullins' marble sculpture of Isaac and Esau that used to greet visitors, somewhat melodramatically, at the north door. Gone too are the totem pole, many children's favourite, and inevitably the ridiculous but endearing dinosaur models. (Too cherished to destroy, these are now in storage at GMRC, with the exception of one that, sadly, disintegrated when moved.) In the long list of items coming back out of storage, however, are the popular winter/summer diorama, showing animals and birds in their seasonal pelts and feathers, and parts of the Mackintosh tearooms. Having taken nearly nine years to restore, and only once been seen on display in a temporary Mackintosh exhibition, this takes centre stage as one of the gems in the new display. To replace the silly dinosaurs, a new life-size model of a *Ceratosaurus* roars into prime

position in the Creatures of the Past gallery in the west wing, and a dazzling selection of Egyptian artefacts, on long-term loan from the British Museum, now joins Kelvingrove's already impressive collection.

This was the plan, these are the works, and this today is the outcome. All of it was achieved on budget and delivered on the exact dates expected, despite the team having had half the time that it was predicted would be required to complete the project.

Everyone involved in this gargantuan public project hoped that this radical overhaul of the building and the sensitive revitalization of the collection would not only delight the citizens of 2006 Glasgow, but also stand the test of time sufficiently to be doing so for many decades to come. Few people, this author amongst them, would disagree with the evidence that they have been spectacularly successful in achieving this. The new building and displays are nothing short of an utter triumph, a testament to how those in public office can do more than just organize bin collections and paint double yellow lines on kerbs, but still make those big, creative, thrilling and historic decisions that mark out a city and the ambitious cultural aspirations of everyone who lives in it.

The restored and redisplayed Kelvingrove is the culmination of 15 years of work by hundreds of Council staff.

Pictured opposite: Just a few of the many Council staff who were proud to play a part in the restoration of Kelvingrove.

PEOPLE AND EXHIBITIONS

Kelvingrove: Glasgow's portal to the world

Top: Staff and architect sampling the new restaurant in 1923.

Above: John Fleming, Curator of Technology 1906–30, Assistant Director 1930–39, Deputy Director 1940–49.

The history and fortunes of Kelvingrove do not rest entirely upon the deeds of the great benefactors and the city fathers. For the last century the staff of Kelvingrove have worked tirelessly to make and keep this great institution the jewel in Glasgow's crown. Over the years the important directors have been lauded in print, and occasionally in portraits, but as in almost every other organization, the history of the art gallery and museum suffers from the injustice that there are so very many more people who have contributed to its success but who have neither been acknowledged nor remembered.

Past Superintendents and Directors

James Paton

In that conservative tradition of recalling the great and the good, clearly first to make an impression was Superintendent James Paton. Curators and museum directors in the nineteenth century, in all but the very largest institutions, were mostly regarded as enthusiastic amateurs who did their jobs out of a passion for the subject or a sense of civic duty. Paton was one of the pioneers who helped transform the task of running a museum into a serious profession. Although trained as a lawyer, he ended up accepting a position in the Industrial Museum in Edinburgh in 1861, where he remained for 15 years. In 1876 he came west to Glasgow to take charge of the City Industrial Museum and the Corporation Galleries in Sauchiehall Street which housed Archibald McLellan's bequest.

What marked Paton out was his desire to see Glasgow at the forefront of the museum world, rather than being regarded as provincial and irrelevant. To this end, he visited an

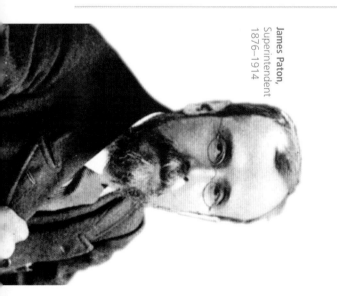

James Paton,
Superintendent
1876–1914

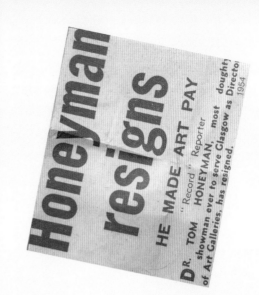

Honeyman resigns

HE MADE ART PAY

DR. TOM HONEYMAN, most doughty showman ever to serve Glasgow as Director of Art Galleries, has resigned.

"Record" Reporter

1954

Rennie, Brotchie and Eggleton

Thomas Rennie filled in as acting superintendent after Ramsay's tragic death until 1919, when Theodore CF Brotchie was appointed. Brotchie was a local historian, as well as an artist and writer. He published a history of Govan, and possibly his best remembered contribution to Kelvingrove was the setting up of the Glasgow Room. James Eggleton succeeded him in the new post of director in 1930, and published an important catalogue of pictures in 1935.

TJ Honeyman

In 1939, one of the most colourful and best-remembered directors of Kelvingrove was appointed. Dr Tom J Honeyman (pictured right), or TJ as he was known to practically everyone, was a medical doctor whose interest in art led him into the world of art dealing. He gave up practising medicine to join the famous Lefevre Gallery until he was persuaded to take up the post at Kelvingrove.

If Paton's observation was correct about the isolated and enclosed nature of museum directorship, then Honeyman set out to change that. His years in art dealership had taught him the considerable financial and professional benefits of making personal connections and friendships, and to this end

enormous variety of museums and galleries abroad, satisfying both his interest in Old Masters paintings and his curiosity as to how other establishments collected and displayed their treasures. It was Paton's influence that led to the organization of the great exhibition of 1888 and to make plans for the building of Kelvingrove. However, his observation in 1895, that those working in museums suffered from being isolated and lacking in antecedents, indicated that he had ambitions to change perceptions within as well as without the museum world.

Gilbert A Ramsay

When Paton retired in 1914, he was replaced by Gilbert A Ramsay, who had previously worked at London's Whitechapel Gallery. This could have potentially been a period of great innovation for Kelvingrove, since the Whitechapel Gallery was at the forefront of many progressive art movements and of widening access. Tragically it was not to be. With World War I tearing through Europe, Ramsay felt his call to duty on behalf of his country was too strong. He enlisted and was killed in action in the Dardanelles in July 1915, making this the shortest, and surely the most poignant, tenure of any Kelvingrove superintendent.

Honeyman, unlike any of his predecessors, was an enthusiastic socialite and self-promoter. Whilst this drew him criticism from some quarters, probably from those envious of his high profile and impressive address book, there's no doubt that Honeyman's self-assurance and taste for reform had a profound effect on Kelvingrove.

He is of course remembered for having brought the Salvador Dali painting *Christ of St John of the Cross* to Glasgow through his personal contacts with Dali and his agent, but his other achievements were no less impressive. His contacts in the art world led to a number of important acquisitions of French paintings, often with funding from the Hamilton Bequest. Claude Monet's shimmering Mediterranean *View of Ventimiglia*, recently spectacularly cleaned, is the outstanding example. But perhaps his greatest achievement was not related to Kelvingrove at all – in 1944 he negotiated the donation of Sir William Burrell's collection to Glasgow, leading eventually to the creation of a second world-class museum in the city.

Under his directorship the Schools Museums Service was established, a project extremely close to his heart. Honeyman's passion was for teaching an appreciation of art and other cultures to everyone, not just to

an already educated elite, and to this end the Schools Museums Service was the perfect vehicle. Comparing his task to that of the city librarian Honeyman said, 'At least his customers had learned to read. Ours [visitors to Kelvingrove] arrived with an intelligent interest but with more or less abysmal ignorance'.

By introducing schools visits with information provided by curators, experts and indeed even Honeyman himself, his aim was to nip that ignorance in the bud from childhood. It goes without saying what an outstanding success this approach has been, and indeed has become the norm in almost every similar institution in the world. But it's sobering to remember that it was as late as 1941 when he launched the service.

Part of the brief was the inheritance and revitalization of the annual schoolchildren's drawing competition, started in 1904 but which had lost momentum.

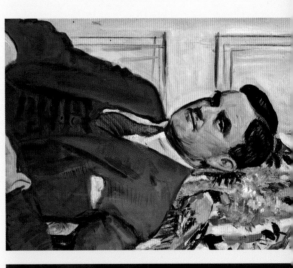

Left: *Dr Tom Honeyman* by Leslie Hunter, bought with the assistance of the Heritage Lottery Fund and Friends of Glasgow Museums.

Right: The annual art competition, 1950s.

Honeyman breathed new life into this by getting schools to bring their pupils along, and it quickly became one of the most cherished memories that Glasgow schoolchildren retain of Kelvingrove. As a schoolgirl I was not immune to this joy. It's impossible to fully communicate the utter bliss of being granted an entire day in the palatial quietude of Kelvingrove, being allowed to select any exhibit at will, given a metal chair and a piece of hardboard on which to pin one's paper, and left to sketch and contemplate this object of desire for as long as it took. I can genuinely say that it was during those competition days that I felt most personal ownership of the art gallery and

museum, the feeling that this place of beauty and endless fascination was ours to savour and that our pencil sketch of an otter or an African mask somehow eternally marked our presence within it.

Sadly I never won, but other losing participants can reassure themselves with the knowledge that amongst the winners was a young artist called Elizabeth Blackadder. With competition like that, perhaps our failure is a little easier to bear.

In addition to the Annual Art Competition for Young People, Honeyman was also innovative in his approach to the conservation and cleaning of paintings, in the way the museum was perceived in the wider world by setting up the *Scottish Art Review*, and also the way objects were stored and catalogued. He reconsidered the nature of object arrangement, an early understanding that displays had a variety of functions that exceeded the Victorian ideal of straightforward presentation. In September 1944 he founded the Glasgow Art Galleries and Museums Association, now one of the longest established Friends organizations in the UK. It's fair to say that TJ Honeyman was one of the most important and colourful directors Kelvingrove employed and that his legacy is still keenly felt, even into the 21st century.

Stuart MK Henderson

When Honeyman retired from the post in 1954, the new director was Dr Stuart MK Henderson. Henderson had a scientific background rather than an artistic one, and most of the museum displays, which lasted until the closure for the restoration in 2003, were created under his directorship. Henderson was, however, far from uninterested in matters artistic, and indeed the missing *Head of a Man* from *The Adulteress Brought Before Christ* was bought during his time, and a great many improvements were made to the art displays.

Trevor Walden

In 1972 Trevor Walden took over the post. One of his great innovations was to start the in-house design department, a move that led to a great deal of modernization in display and literature. He also initiated the Decorative Arts department – responsible for helping raise the profile of the previously ignored Charles Rennie Mackintosh – purchased the Van Gogh *Portrait of Alexander Reid*, and brought the stunning exhibition of Dali's jewels to Glasgow. It was during his directorship that the famous ship models left Kelvingrove in 1977 for their new home at the Museum of Transport (then in Albert Drive). Walden's directorship ended sadly, as he died in office in 1979 at the age of 62.

Trevor Walden (*right*) with Roy Strong, Director of the V&A.

Alasdair Auld

Walden's successor, Alasdair Auld, was another director with an art background. His achievements included the replacement of the ship models with the armour collection, creating a dedicated, adaptable temporary exhibition space on the ground floor, redisplaying the galleries that had lost their exhibits to the new Burrell Collection, and purchasing the popular painting Faed's *The Last of The Clan*. Of course, the major achievement of his directorship was the long awaited completion of the new building to house the Burrell Collection, in 1983.

Julian Spalding

The year 1989 saw new directorship in the form of Julian Spalding. Formerly Director of Manchester Art Galleries, Spalding was regarded by some as outspoken and controversial as TJ Honeyman had been, but perhaps for different reasons. Spalding oversaw the 1990 programme of exhibitions that marked Glasgow's triumph as European City of Culture, but his redisplay of the west wing galleries, reordering paintings by artistic theme rather than chronology or schools, caused a great deal of debate.

Even more controversial was his policy on modern art purchasing, called into question by the inclusion of some works that

were not seen by art experts as having any qualities other than populist appeal. Probably the best illustration of this was the paintings he commissioned from Beryl Cook, an artist seen by many as a lowbrow and fey cartoonist best known for works which adorned cheeky greetings cards. And he was dismissive of conceptual art, in which a number of Glasgow artists were achieving international reputations. He continued to inflame passions by refusing to acquire works by the Turner Prize winner Douglas Gordon. When he purchased a work from Scottish neo-classicist sculptor Sandy Stoddart it caused uproar within Glasgow City Council. The piece was a bust of ex-Council leader Pat Lally, entitled

Biederlally and was bought without the Arts and Culture Committee's permission since the price was under the threshold that required approval. Some mistakenly thought this was an inappropriate aggrandizement of an ex-leader, not universally held in high esteem. In fact, Spalding intended the purchase to be quite simply a celebration of the outstanding artistry and mischievous wit of Stoddart.

Spalding continued to make his mark, and made the first attempt at raising money for the restoration of Kelvingrove. He also introduced the concept of 'story displays' which, he insisted, should be cross-disciplinary wherever possible.

The Present

Liz Cameron

Glasgow's third female Lord Provost has also had a considerable influence on the fortunes of Kelvingrove. As Deputy Convener and then as Convener of the Arts and Culture Committee, Liz Cameron was a key figure in the repatriation of the Ghost Dance Shirt, mentioned elsewhere in this book. As Convener, Cameron was actively involved in bringing together libraries, art galleries and museums, arts, theatre and music, sports and leisure and community learning into one new

department of Cultural & Leisure Services. Under her Convenership, the City Council agreed the Kelvingrove New Century Project and the building of Glasgow Museums Resource Centre. She has continued to support these projects whilst Lord Provost, and Kelvingrove's restoration will undoubtedly be one of the greatest legacies of her term in office.

Mark O'Neill

In 1998, Glasgow Museums underwent a reorganization and two people took over the responsibility for Kelvingrove. Mark O'Neill, who had worked in the Museums Service since 1990, was appointed Head of Museums and Galleries. Bridget McConnell took over as Director of Cultural & Leisure Services, the department that oversees museums and galleries in addition to other areas of

Glaswegian cultural life as diverse as kicking a football and dancing Swan Lake.

Mark O'Neill came to the position from a background that had seen him establish a highly successful community museum in the deprived district of Glasgow's Springburn, originate St Mungo's Museum of Religious Life and Art in 1993, and led the team that refurbished the People's Palace. He has been one of the major driving forces behind raising the Heritage Lottery Fund money for the restoration of Kelvingrove, and creating the intellectual framework required to hold the displays together. His energy and commitment have demonstrably reaped considerable rewards. Under his leadership, O'Neill has already made many significant contributions, including the setting up of Glasgow Museums Resource Centre in Nitshill. He was also

Mark O'Neill, Head of Arts and Museums

Lord Provost Liz Cameron

responsible, along with Councillor John Lynch, for devising the process for assessing claims for the repatriation of items that were of a sensitive cultural nature to the people for whom they remain sacred. These include the Ghost Dance Shirt to the Lakota Sioux and Maori toi moko to the Te Papa Tongarewa Museum in New Zealand. This has sometimes been controversial, raising the argument about whether a museum should recognize the sacred or merely display objects in a spirit of neutral anthropological and intellectual distance. However, the Working Party's decisions have largely met with approval from both the cultures concerned and the people of Glasgow on whose behalf it has acted. O'Neill continues to oversee Kelvingrove with commitment and passion, and a clear vision of how it will continue into the next important decades.

Bridget McConnell

It will not have escaped the attentive reader that the appointment of Bridget McConnell (*pictured above*) as the ultimate executive responsible for Kelvingrove is of outstanding historical importance, given that this was the first time a female was appointed at senior level in Kelvingrove's history for 97 long years. Shocking as this oversight was, McConnell's

outstanding contribution has more than made up for the century of misogyny that kept women in their place and out of positions of power. With an art degree from St Andrew's behind her, she has embarked on a career almost entirely devoted to the support and promotion of the arts in Scotland including, amongst many appointments, principal arts officer for the arts in Fife, being a member of the Scottish Arts Council Combined Arts Committee, and being a founder member and previous chairperson of both the Scottish Local Authority Arts Officers Association and the Scottish Youth Dance Festival. Her brief for Kelvingrove was to bring it up to date, make it more accessible and relevant and to keep ignited that pilot light of civic pride that Kelvingrove has unfailingly burned in Glasgow's citizens. None can deny that she has achieved this spectacularly, and her

unfailing commitment to promoting and expanding the reach of the arts in Glasgow, in addition to her almost forensic professionalism, has ensured that the 97-year wait for a woman to be in charge has not been in any sense an anti-climax.

Unsung heroines

Isabel Mackintosh

Although Bridget McConnell is the first woman in charge of Cultural & Leisure Services, many women have contributed to Kelvingrove's success over the years, and given the prominence of men in this brief history it would be remiss to ignore them. Isabel Mackintosh was a much-lauded figure in Kelvingrove, having joined the staff in 1935. She acted as

Isabel Mackintosh with Dr Honeyman at his 80th birthday celebrations.

Jean Irwin models a dress from the costume collection, seated on a Charles Rennie Mackintosh chair.

TJ Honeyman's personal assistant, but ran GAGMA, the Glasgow Art Galleries and Museums Association (now FoGM, the Friends of Glasgow Museums), edited the *Scottish Art Review* and was responsible for most of Kelvingrove's publicity. Although she never rose to the heights within Kelvingrove's hierarchy, Honeyman is on record as having valued her highly, and it may have been a sign of the times rather than Mackintosh's inadequacy that prevented any serious promotion.

Irwin, Annand, Donald and Adamson

Jean Irwin was also a female of note, the first full time teacher in the education department and her enthusiasm and passion for her job won her an MBE for her services. Louise

Annand became the head of the Museums Education department in 1969, and the first two women to become heads of curatorial departments were Anne Donald in Fine Art in 1979 and Helen Adamson in Archaeology, Ethnography and History in 1981.

Jean McGrellis

Interestingly, when current staff members were quizzed about significant female contributors, amongst the academic, curatorial and educational staff mentioned another figure stood out. Jean McGrellis, the unflappable and cheerful head cleaner for 32 years until her retiral in 1982, is remembered as pivotal to the smooth running of the building. Regardless of the fact that she was employed in one of the traditional low status women's occupations, and therefore bound to be overlooked in any conservative overview of the history of Kelvingrove, she is symbolic of the many anonymous and hard-working staff who contributed to the success of Kelvingrove by their loyalty and unfailing commitment to the job. Add to this the fact that she regularly won the Glamorous Granny contest when on holiday, and Jean McGrellis deserves to be remembered for more than just dusting the dinosaurs and mopping the floor under the Rembrandt!

Louise Annand and her predecessor, Sam Thompson.

this is one of the oldest established Friends' organizations in the UK

Above left: Mark O'Neill accepts Bridget Riley's screenprint *Sylvan* from Peggy Moorhouse of FOGM, 2002.

Above right: Friends' raffle in 1983. Left to right; Mansel Dinnis (British Caledonian Airways), actress Kate O'Mara, Mr & Mrs Brian Cook (prizewinners), British Caledonian air hostess, and Tim Honeyman, then Chairman of the Friends.

Friends of Glasgow Museums

A book on Kelvingrove could not fail to mention the contribution of the Friends of Glasgow Museums (FoGM). Founded in September 1944 to cultivate interest in, and to support, the activities of Glasgow Museums, this is one of the oldest established Friends' organizations in the UK.

Through their membership and fund-raising activities, they contribute many thousands of pounds each year towards the purchase of works of art and other objects, as well as sponsoring the Annual Art Competition for Young People and other activities. Indeed, the restoration of Kelvingrove's organ in the 1980s was due to support from FoGM, and this support continues into the 21st century. The new lecture theatre, funded by the Kelvingrove Refurbishment Appeal, is largely the result of

the perseverance of the late Betty Campbell, a long-serving member of the Friends' Committee. In addition, the stalwart Volunteer Guides provide free guided tours round many of the City's museums, including Kelvingrove.

It takes many people to keep an institution as great as Kelvingrove running. Aside from the curatorial staff, there are the conservators, the design team, the security staff, the cleaners, the caterers, the maintenance staff and a whole host of others who keep peddling away behind the scenes so that the peaceful facade of smooth running professionalism never cracks. The new century thankfully sees a much more healthy modern mix of men and women, working together to keep this wonderful building and its collections protected and enhanced for generations to come.

ART GALLERIES WAY OUT →

1946

"That Picassy bloke's no' as guid es yon men in armour felly that done auld Rembrandt."

—By BUD NEILL

IN GLASGOW ART GALLERY—

Happy Saturday Mornings

FOR YOUNG ARTISTS

195

1957

FINDING A HOME FOR THE BURRELL ART COLLECTION

Difficulties of gift conditions

ART GALLERY OUTRAGE.

— 1912 —

Kelvingrove Picture Glass Smashed with Hatchet.

—

WOMAN SUPPOSED TO BE SUFFRAGETTE.

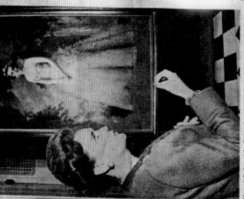

YOUNG GOLD MEDALLISTS IN ART CONTEST

1931

DON'T BUY THE DALI PAINTING, SAY ART STUDENTS

GLASGOW art students are protesting against the proposed £8200 purchase of Salvador Dali's "Christ" for the city's Art Galleries. 1952

SIR JOHN LAVERY (right) with Mr. David Guild (middle) and a friend at the Century of Art in Glasgow Exhibition in the Art Galleries, Kelvingrove, Glasgow. Sir John is one of the famous Glasgow school of painters. 1935

1977

TWENTY-FIVE GLORIOUS YEARS EXHIBITION

GLASGOW'S MUSEUMS ARE celebrating the Queen's Silver Jubilee with an exhibition which features many of the finest items during her reign.

1948

Hanging one of the pictures by van Gogh, the Dutch painter, in readiness for the exhibition which opens at Kelvingrove Art Galleries on Saturday.

THE ART GALLERIES, KELVINGROVE. 1922

—

FREE PUBLIC LECTURES.

—

"DEVELOPMENT OF THE MODERN DIESEL ENGINE"

(WITH LANTERN ILLUSTRATIONS)

Dr. MELLANBY

On TUESDAY EVENING at 7.30.

THE LECTURE on "ART IN EDUCATION" by Dr VAUGHAN is POSTPONED until TUESDAY, 7th

Glasgow Girls shine, despite feminist slant

As a new show of women's art opens in Glasgow today, GIBBON WILLIAMS gives a man's view

1905

E PLEBISCITE

GALLERIES TO OPEN ON SUNDAYS.

—

ECISIVE MAJORITY.

—

AILS OF THE VOTING.

st—	53,389
	45,181
Majority in favour	8,208

1971

he Master stroke...

'Missing' painting is home

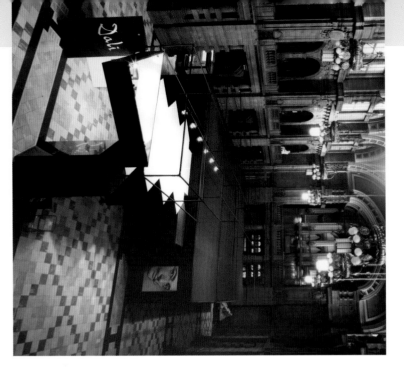

Above: *Dali's Art in Jewels* exhibition 1973–4.

Opposite: a selection from the many exhibitions at Kelvingrove. Clockwise from top left, *Claws* (1997); *Dancing Through Time* (1992–3); *Keeping Glasgow in Stitches* (1990); *Joan Eardley Memorial* (1964); *Curling in Scotland* (1985); centre the Queen arriving to view *25 Glorious Years* (1977).

Exhibitions

Kelvingrove Art Gallery and Museum has not just delighted visitors over the years with the dazzling variety of its own permanent collections, but also with the temporary and visiting exhibitions it has hosted over the last century.

Dali's Jewels

Of the many I visited over the years, the one that made most personal impact was *Dali's Art in Jewels* (October 1973–January 1974). The demand for this was absolutely enormous, and I recall as a child waiting for nearly two hours in a queue that snaked right round the building and into the park. However, once inside the sight of the exhibits was so intoxicatingly exciting and exotic that all those who had waited deemed the inconvenience irrelevant. Dali had constructed surreal images from some of his most famous paintings in three dimensions, using precious metals and jewels, and the result was both bizarre and beguiling. I stood as long as I was able, given the pressure of the excited crowd, gazing at the spindly-legged elephant and drooping watches encrusted in diamonds. The enigma of these objects stayed with me for many years. This was one of the Kelvingrove's biggest crowd pullers, but there have been many more of great significance.

Other milestone exhibitions

Art exhibitions in the 1940s, brought to Glasgow through Tom Honeyman's contacts, included some major touring ones of Picasso, Matisse and Van Gogh, and later on in the century, a major exhibition of French paintings entitled *The Realist Tradition* was so extensive that the entire east wing picture galleries had to be cleared to accommodate it. In 1948, an exhibition of Princess Elizabeth's (now Queen Elizabeth) wedding dress drew in 139,175 visitors in just 13 days. The *Joan Eardley Memorial Exhibition*, in 1964, was a fitting tribute to one of Glasgow's and Scotland's greatest adopted artists. However, her depictions of slum children were misunderstood and criticized by some as showing Glasgow in a poor light.

In 1990, an exhibition of Rembrandt's paintings, *Rembrandt by Himself*, was an enormous hit with visitors and critics alike, unlike an exhibition of Stanley Spencer's marvellous Clyde shipyard-inspired paintings in 1994, which curiously was slated by Clare Henry, the *Glasgow Herald's* irascible art critic. A major exhibition of east coast artist John Bellany's works dominated the east wing galleries and the centre hall, and was graced with the presence of pop legend David Bowie who travelled to Glasgow specifically to see it.

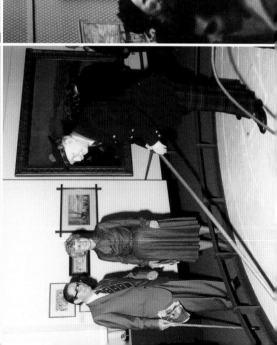

I recall as a child waiting for nearly two hours in a queue that snaked right round the building and into the park

Above: *Glasgow Design Today*, 1999

Above right: *Stanley Spencer and the Shipyards*, 1994

In 1997, *Scrolls from the Dead Sea* had more queues forming outside the door, due to the historic and religious significance of the exhibits, and *St Kilda Explored* in 1995 was seen as a milestone in celebrating the lives of the closed community that had fascinated Scots for the century since their first introduction to the modern world. It also provided an opportunity to test new methods of interpretation, the shape of things to come in the Kelvingrove New Century Project.

Exhibitions that required a little more effort than simply hanging up paintings included the 1985 *Curling in Scotland* exhibition – this demanded a great deal of experimentation from curatorial and design staff to create an ice rink in the temporary

exhibition space! Equally, the *Keeping Glasgow in Stitches* exhibition in 1990 had to be designed to host a massive sewing project in the centre hall, resulting in the creation of a dozen magnificent banners.

In 1995, a groundbreaking exhibition entitled *Out of Mind Out of Sight* explored the difficult and often taboo subject of attitudes to mental health in Scotland. Despite the sensitive material this was a great success, raising awareness and forcing many visitors to confront prejudices and preconceptions they had previously ignored. As a result, the exhibition won a well-deserved award and set the tone for other exhibitions, and indeed displays, that would later deal with equally thorny subject matter.

*Horse shoeing outside the Art Gallery and Museum, one of the events linked to **The Year of the Horse** exhibition*

1990

PREHISTORIC EXHIBITION
KEEPS IN TOUCH WITH
TODAY

1993

Banners of the World, 1992

10,000 Queued For Last View Of Picasso's Paintings

1946

By A "Daily Record" Reporter

PEOPLE—10,828 of them—queued in the rain in a slowly moving stream outside Glasgow Art Galleries, yesterday afternoon, to catch a last glimpse of the Picasso-Matisse exhibition.

The show has been an exhibition staged at Kelvingrove record.

The figure count, taken when the exhibition ended at 3 p.m., showed that more people had visited the galleries especially to see Picasso and Matisse. Peak day was Sunday, Feburary 3, when 11,196 were admitted.

The Future

The restored Kelvingrove is going to be well placed to continue this success in temporary and touring exhibitions, not just because of the modular nature of its display systems, but also because of the creation of the environmentally controlled area in the new lower ground floor. This will mean that touring exhibitions of international status that require strictly controlled conditions can now include Kelvingrove as a possible venue. Rest assured that the next century will be just as exciting as the last – and queues around the block are not going to be something of the past.

POSTSCRIPT

Pupils from Glasgow schools designed tiles to decorate the corridor of the Education suite.

On 29 June 2003, when Kelvingrove closed its doors on a century of its history to begin the journey into the next century, there were wails of dismay from those who couldn't bear to part with it for even a few short years. In the two years before closure, visitors were invited to complete memories slips, and later a website was set up for visitors' memories of Kelvingrove. Some of them are quite exceptional.

A woman who emigrated to Canada recalled having bumped into her lost Glaswegian love there on a brief visit home after an absence of 33 years. One man recalled being perpetually embarrassed because he always cried in front of his favourite painting. The sound of children's sandals slapping on the marble floors and trying to tiptoe to keep the noise down was the memory of another visitor. Perhaps the most universal of all the memories came from an anonymous person from the USA who said simply, 'Just walking in the door gave me goosebumps'.

To have created a building and collection that has touched and inspired so many people in so many different ways is a magnificent achievement, reflecting the ambitions and the intentions of the original city fathers who created Kelvingrove Art Gallery and Museum.

Despite any criticisms and anachronistic stereotyping to the contrary, we Glaswegians are a cultured people, helped to be so by the unlimited access to treasures like Kelvingrove. The stories it has told us, the visions it has shared, and the wonder it has ignited are gifts of immeasurable value, and it's to the credit of the people of Glasgow and Scotland that they have never, ever, taken it for granted.

Who knows what shape the world will be in during the coming tumultuous years of this new century? All we know for certain is that Kelvingrove, that magic portal to the world and everything in it, will continue to shine as a beacon of civilization, learning, cultural understanding, and optimistic appreciation of what makes our world mostly wonderful as well as occasionally terrible. Let's put it more simply:

Kelvingrove – thank you.

INDEX

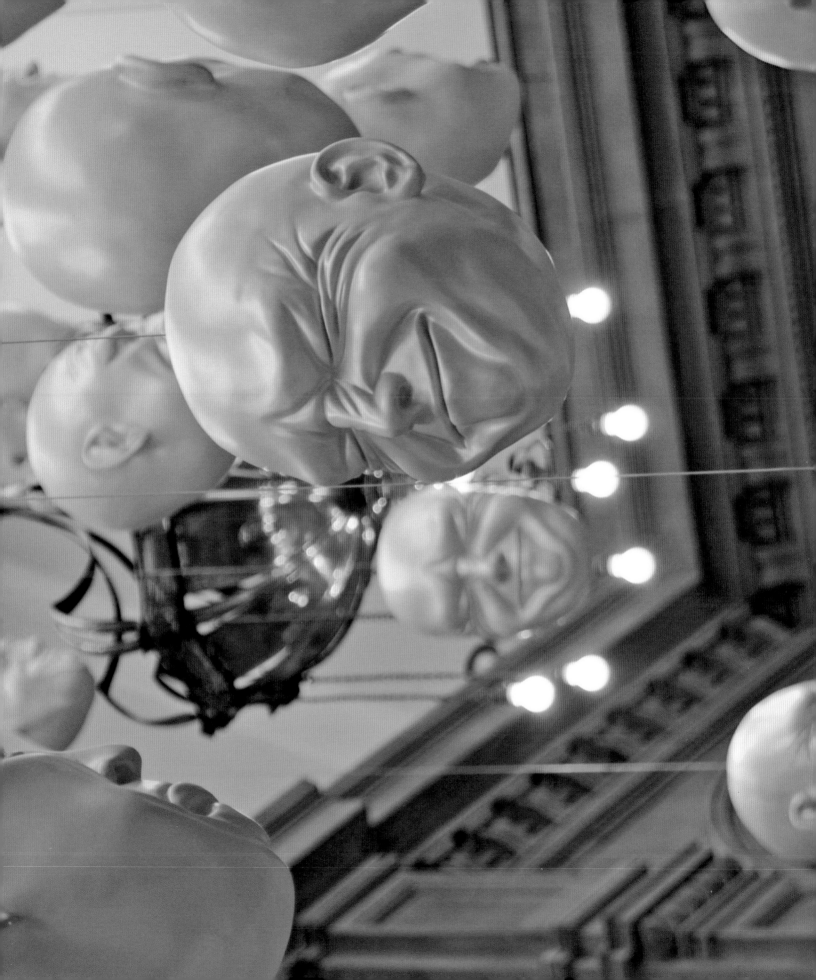

KELVINGROVE ART GALLERY AND MUSEUM

Glasgow's portal to the world